FALMOUTH

FALMOUTH

DIANNE D'COTTA

The History Press

First published 2021

The History Press
97 St George's Place, Cheltenham
Gloucestershire GL50 3QB
www.thehistorypress.co.uk

British Library Cataloguing in Publication Data.
A catalogue record for this book is available from the British Library.

ISBN 978 0 7509 9422 4

Typesetting and origination by The History Press
Printed in Turkey by Imak

INTRODUCTION

Living at the seaside is special.

Living in a coastal town like Falmouth is a privilege – no wonder it made the *Sunday Times* list of great places to live! They described it as an 'all season arty-party town'. With its university specialising in the arts, its bohemian bars and an extensive calendar of events and festivals that punctuate the year, the description is apt. But Falmouth is more than that. This tourist destination is not sterile, but authentic and real, lively and rough around the edges. It is a working port steeped in history, with Pendennis and St Mawes Castles, the sixteenth-century fortresses built by Henry VIII guarding the estuary. Mysterious opes and passageways afford glimpses of the sea and, from the waterside, one can watch a wealth of maritime life. The ever-changing light over the harbour is a constant source of joy.

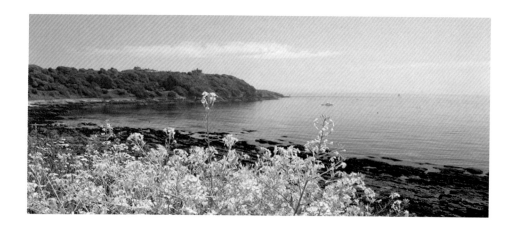

Exotic sub-tropical plants adorn the parks and seafront. No high-rise hotels and commercialized promenade here, but profusions of osteospermum, agapanthus, succulents and wild flowers form jaw-dropping backdrops to the beaches and sea. Not that far away are places of timeless tranquillity: along the Helford River, on the Roseland Peninsula, and the streams flowing through the Glasney Valley in Penryn, there are boundless opportunities to enjoy nature.

There are literary connections, including Kenneth Graham who penned letters to his son while staying at the Greenbank Hotel, and these letters became the foundation of the children's classic *The Wind in the Willows*. Daphne du Maurier, in her novel *Frenchman's Creek*, made the Helford River famous.

Falmouth has been the setting of several films. I remember when Brad Pitt was in town, filming scenes from *World War Z* off the coast. I watched a German company filming extracts from a Rosamund Pilcher book outside the library on the Moor, all traces of the modern day removed for this period drama.

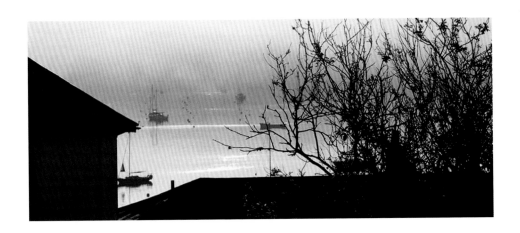

The harbour has been the starting and finishing point of epic round-the-world voyages by Sir Robin Knox-Johnson and Dame Ellen MacArthur. In 2005 I stood amidst the euphoric scenes of welcome that greeted Dame MacArthur in Falmouth, and watched the giant Omega clock tick down on Events Square – 71 days 14 hours 18 minutes and 33 seconds at the end of her single-handed round the world voyage on *B&Q/Castorama*.

Thousands attended a re-enactment of the Trafalgar Dispatch that followed Lord Nelson's death in 1805, showing how the schooner *Pickle* landed off Fish Strand Quay and Lieutenant Lapenotiere transferred to Post-Chaise for the journey to London. I saw the Queen in Falmouth in 2002, on her commemorative tour to mark the fiftieth year of her accession. I see the harbour as a huge amphitheatre bringing us free entertainment.

It is this vibrancy and diversity that has me wandering about with my camera trying to capture its essence. My aim in this book is to tell a pictorial story of life in this fascinating town by the sea.

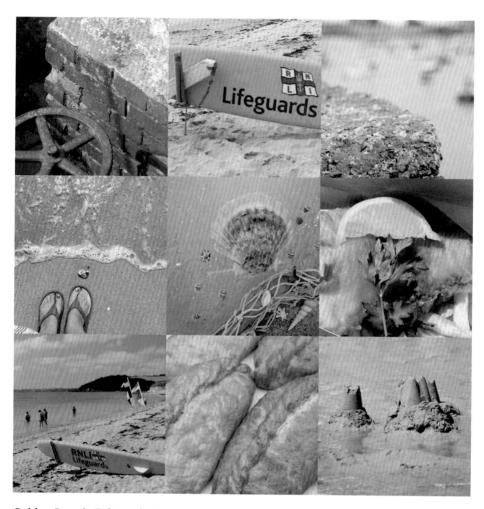

Golden Days in Falmouth. Spectacular skies and images of those halcyon days of summer, before we embark upon a journey through some of Falmouth's landmarks and events of a typical year.

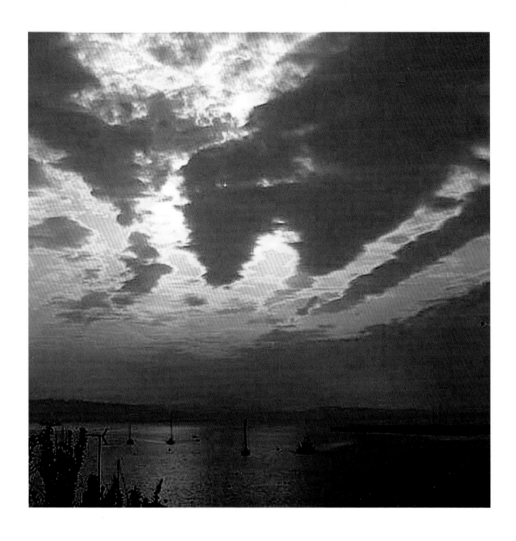

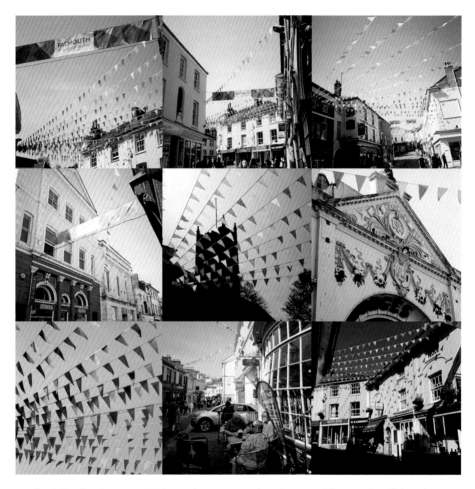

Decked Out for Summer. Falmouth's summer bunting provides a colourful and eye-catching welcome, casting dancing shadows on the walls and pavements. Old High Street is one of the oldest parts of town; the top of the street suffered a devastating fire in 1862, with about 30 premises damaged. Today it houses a plethora of antique/vintage shops and galleries, and has an arty feel.

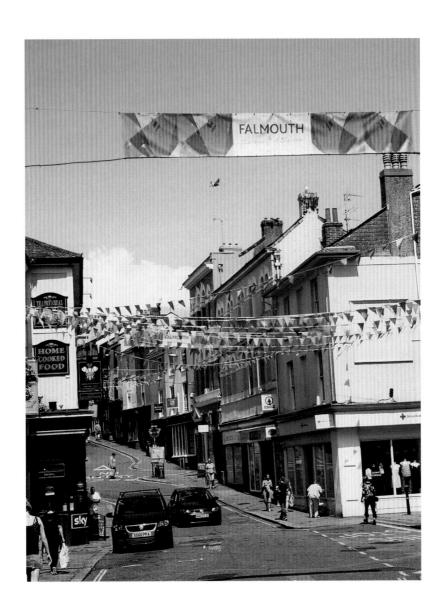

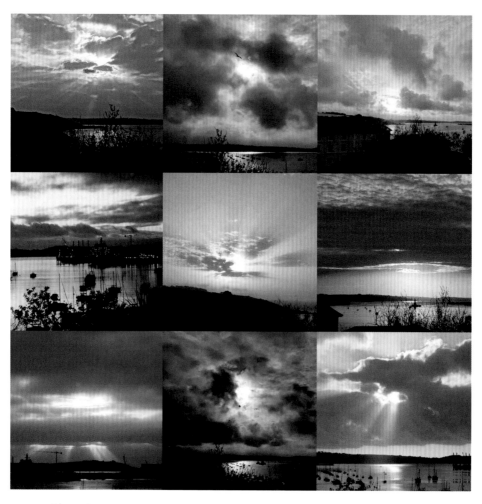

Atmospheric Skies Over Falmouth Harbour. I love cloud watching. Ephemeral and ever-changing in the sky, sometimes iridescent and sometimes forming fans of light – sunbeams are crepuscular rays, which often extend from the clouds in the early morning or early evening. Nature doing its magic!

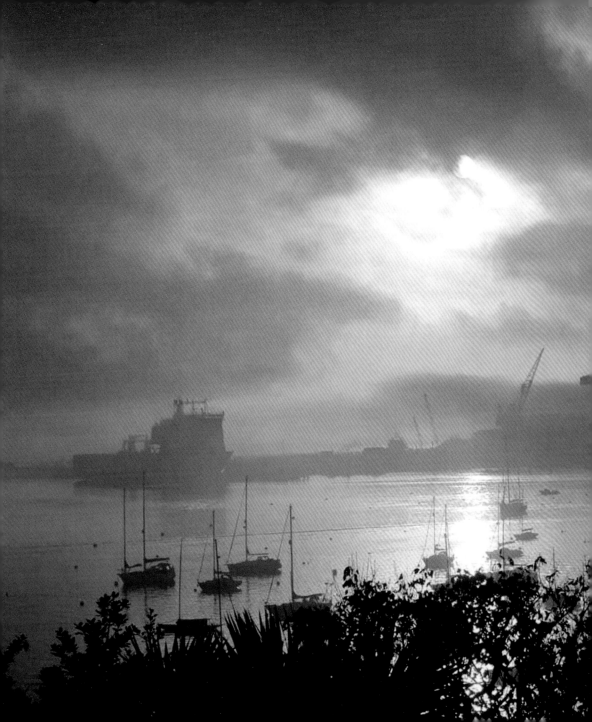

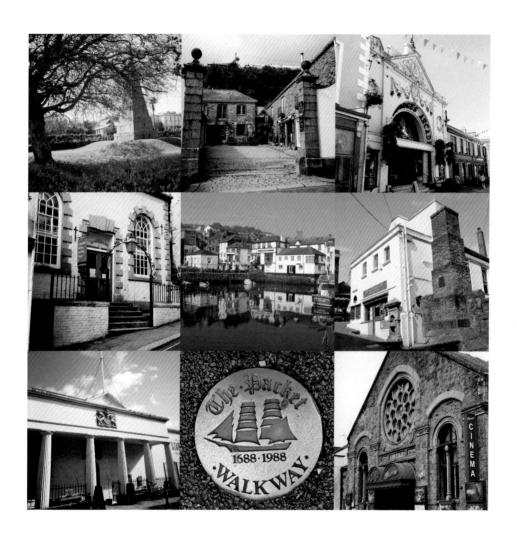

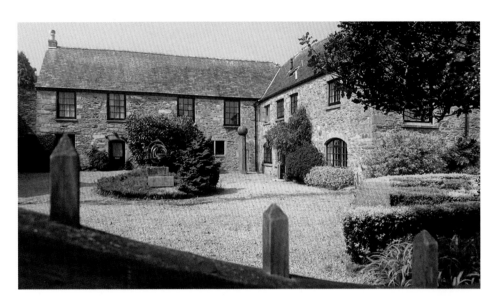

Scattered about Falmouth, old architecture tells a story of the town's history. Interestingly, many of these old buildings have been repurposed. Arwenack House (**above**), originally built in 1385, is the oldest building in Falmouth and was home to the Killigrew family for centuries.

Opposite:

a) The Killigrew monument is named after the founding family.
b) The Old Brewery Yard – once used by Carne's brewery for their drays, horses and barrel store – now contains bars and a plant shop.
c) St George's Arcade now houses shops, but was a cinema when it was built in 1912.
d) The Old Town Hall is now a gallery.
e) The Chain Locker Pub is on the historic quayside.
f) The Kings Pipe, a brick chimney, was used to burn contraband tobacco smuggled onto ships.
g) Customs House in Arwenack Street was built in 1814 – an important focal point for mariners. It is now a restaurant.
h) The Packet Walkway plaques commemorate the Packet Ships.
i) The Old Drill House is now a cinema.

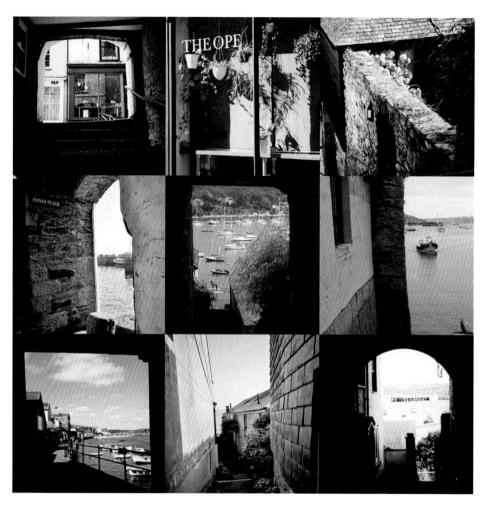

So much history and mystery in these little opes and stairways with windows to the sea. The Barracks Ope, an historical archway built in the seventeenth century leading down to the harbour, was once an entrance to the Royal Marine barracks. It is an often-painted and photographed landmark.

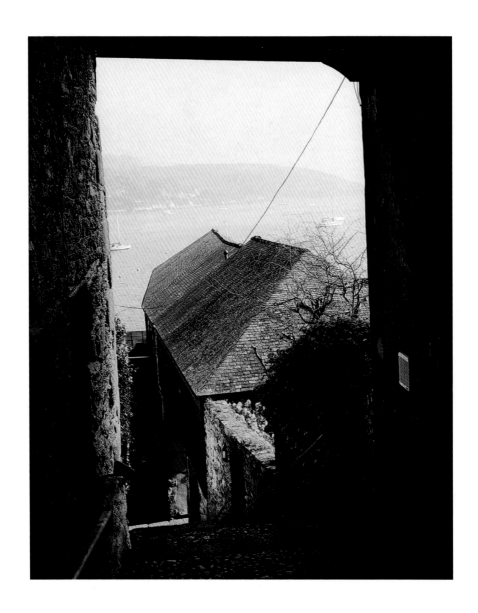

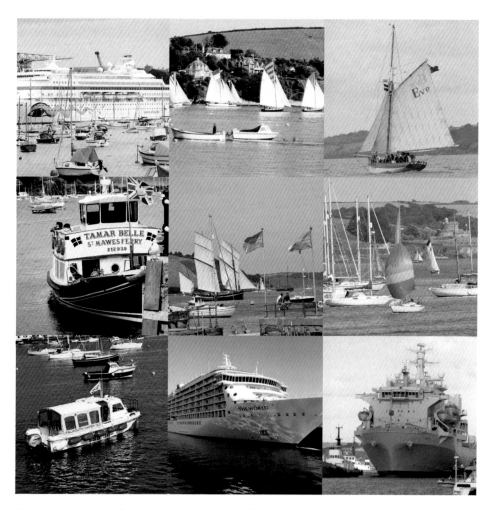

Sea Fever. Watercraft of every description provide so much to watch in the harbour. You'll see everything from sail boats, posh yachts, navy vessels, trawlers, cruise liners, tugs, ferries, water taxis and pleasure boats, to even the simplest of rowing boats pootling around.

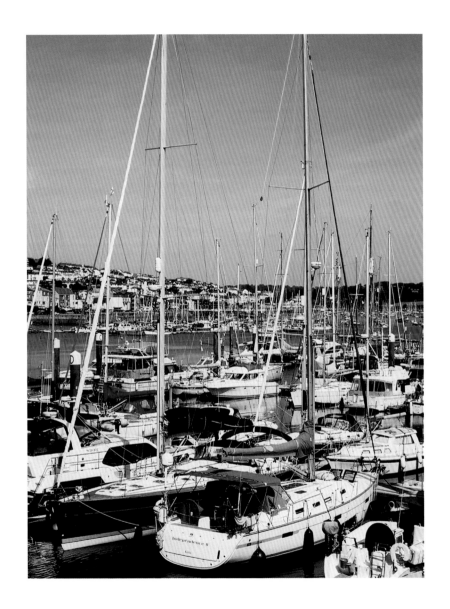

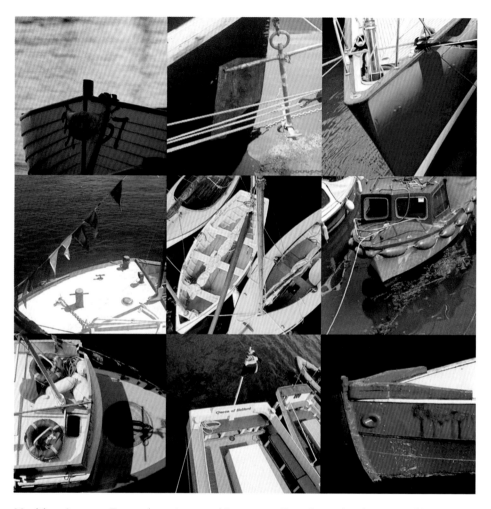

Maritime Images. To me there is something compelling about the shapes and lines found in boats. Encrustations, patina, anchors and coils of rope add to the fascination.

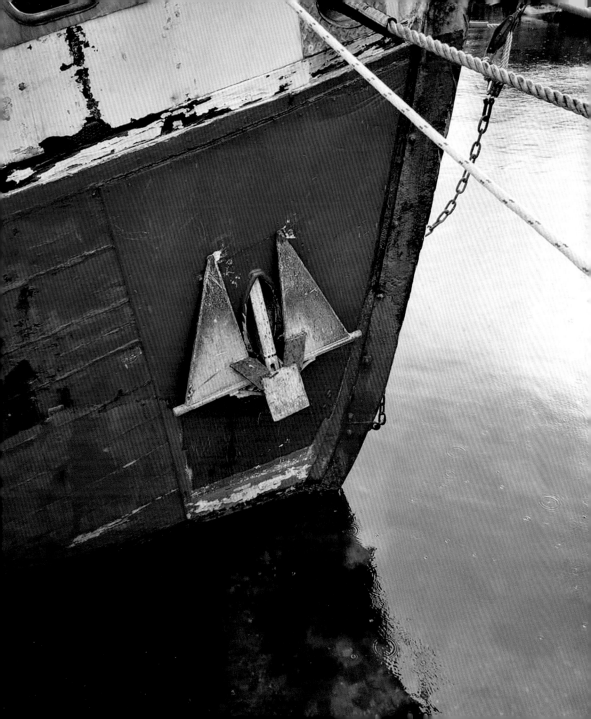

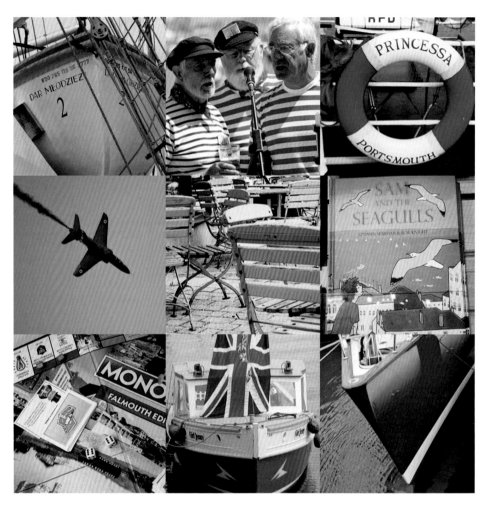

Red, White and Blue. Falmouth even has its own version of Monopoly, exploring the National Maritime Museum, the Prince of Wales Pier and Gyllyngdune Gardens instead of the usual Piccadilly Circus and Bond Street. The red, white and blue bistro chairs at a restaurant on Events Square inspired this grid.

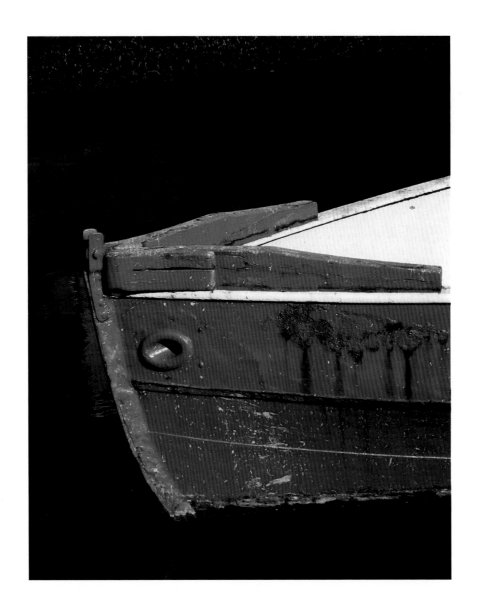

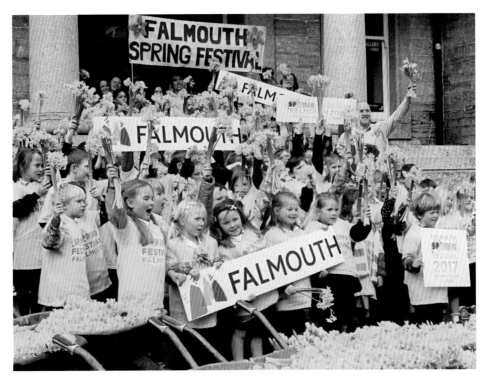

Painting the Town Yellow. The Spring Festival sees shop windows adorned with flowers and spring themes, and young children give out bunches of daffodils to shops and people about town. Even the men doing the roadworks get the special treatment! There are smiles everywhere. No wonder, with a free bunch of nature's sunshine to brighten the day.

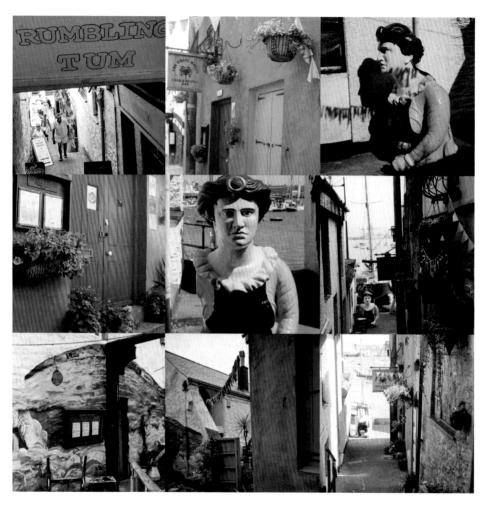

Upton Slip. This colourful alleyway with a seafood restaurant, a pasty shop and an antique shop leads down to the water's edge. The ships figurehead, Amy, draws the eye down from the opening at The Rumbling Tum. A rewarding diversion.

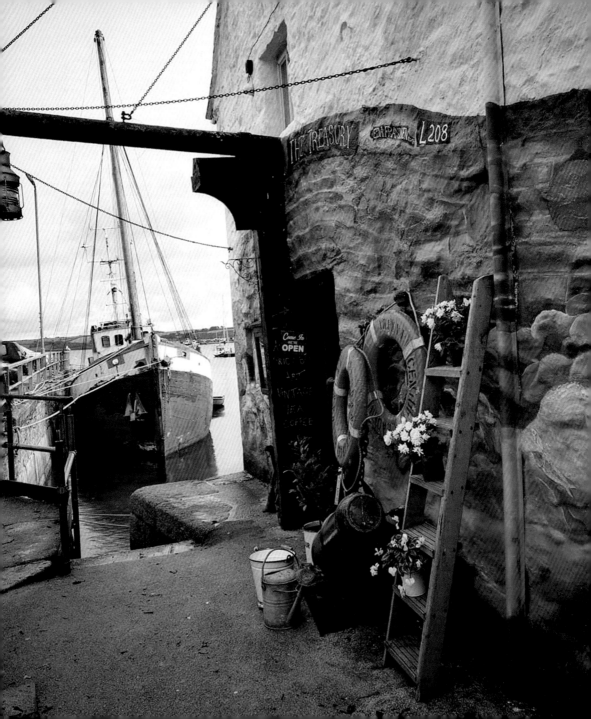

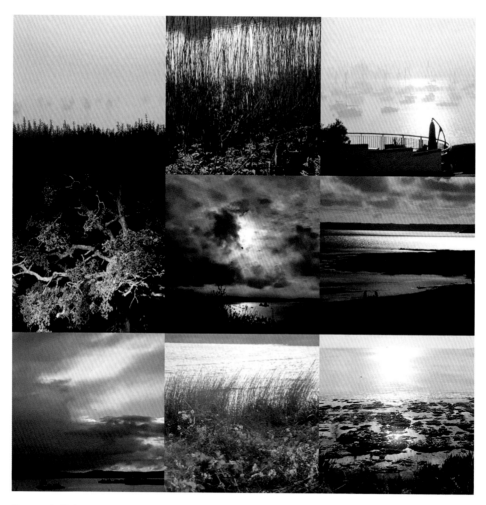

Dramatic light creates contrast, interest and mood. Being out walking when clouds are gun-metal grey and scudding across the sky, or when winds are blowing a hooley or mists shroud the landscape, is invigorating and rewarding for photographic shooting.

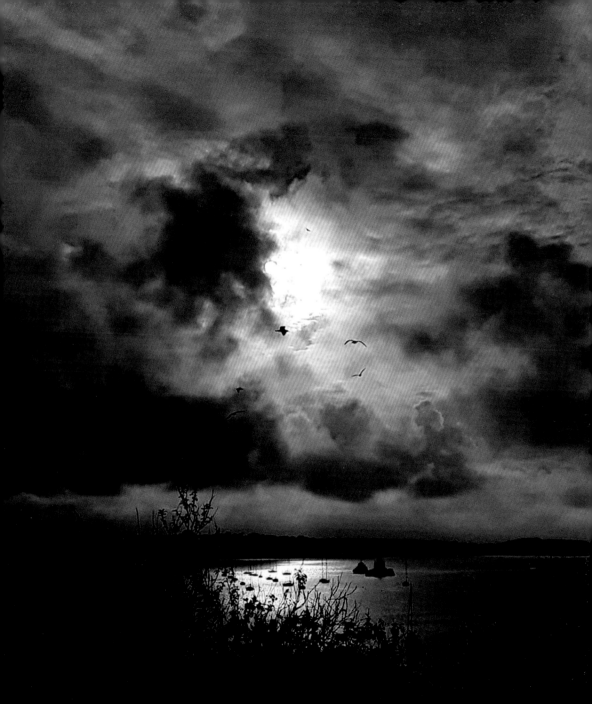

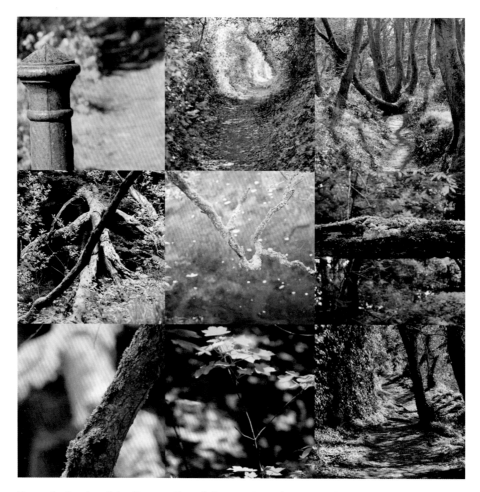

From the banks of the Penryn River follow me into the magical woodland. Earthy smells, the rummaging sound of a squirrel, birdsong, scrunching leaves beneath your feet, dappled light breaking through the trees, the undergrowth of wild flowers, the snapping of twigs and the spongy feel of moss are all so stimulating to the senses. Woodland has a regenerating, calming effect. Oh, the joys of nature!

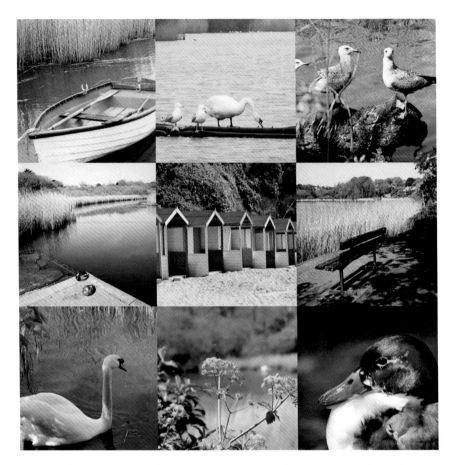

Swanpool Nature Reserve is home to a vast array of wildlife, the mixture of fresh and salt water providing ideal brackish conditions for their survival. Swans, Mallards, Moorhens, Tufted ducks, Coots and even the iridescent Kingfisher may be seen. The nature reserve is a lovely place to walk, to sit and watch the pond life and enjoy the reeds, the yellow flag iris and other wild flowers that grow on its banks. Just over the road is Swanpool Beach, where the beach huts are painted to match the colours of the mallards.

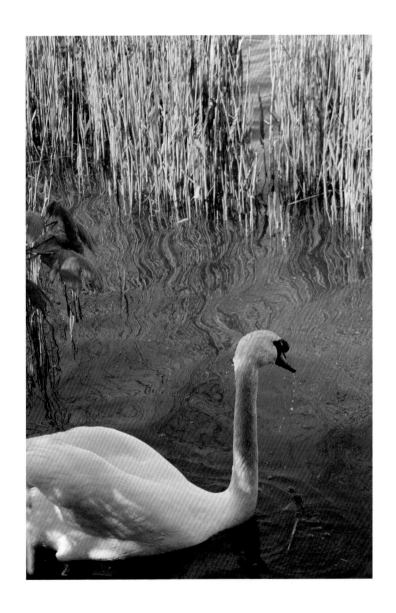

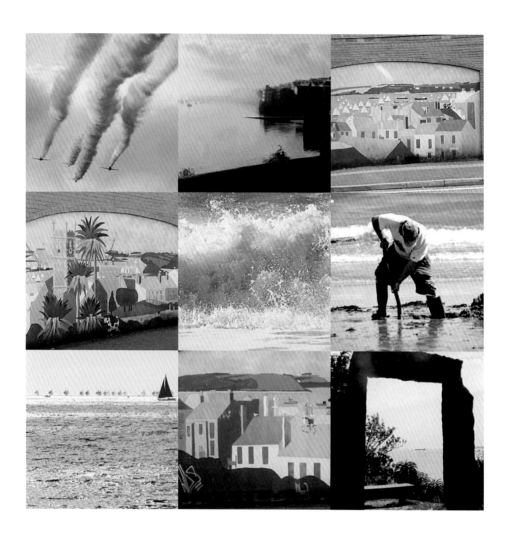

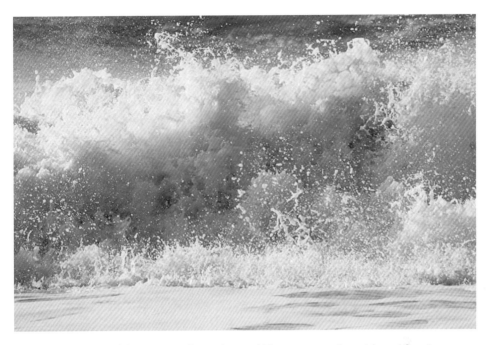

They say the voice of the sea speaks to the soul. The never-ending ebb and flow is certainly relaxing, and has soothing medicinal properties as one sits, mesmerised by the seductive motion. Even in winter one can enjoy its benefits with a brisk walk.

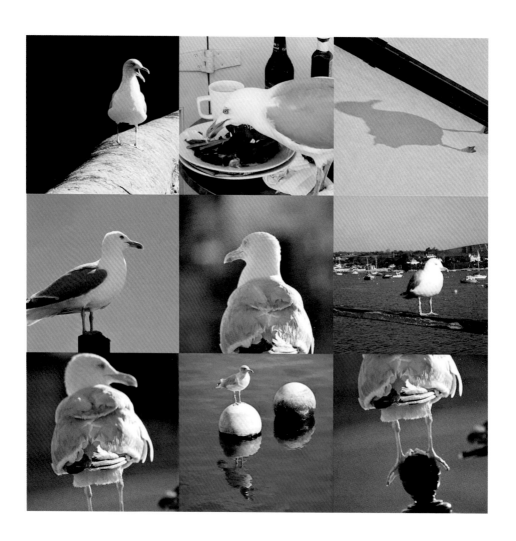

Through the Eyes of a Seagull. One can be awoken by their squawks, appalled when they rip open rubbish bags or swoop in for your pasty, but the fault lies with humans for feeding them and leaving out tempting bin bags of ripe-smelling food. It's not surprising that they see us as their meal ticket. They are, indeed, an intelligent species and fascinating to watch.

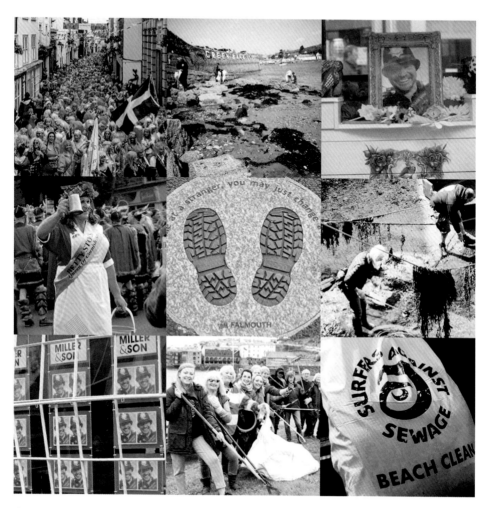

Community spirit in Falmouth is alive and well. There are fund-raising parades, beach cleans, garden tidies, coffee mornings and quiz nights – but, for many, the most meaningful of all was the 6,000-strong memorial walk for PC Andy Hocking. He was described as the 'heart of the community', and passed away in 2015.

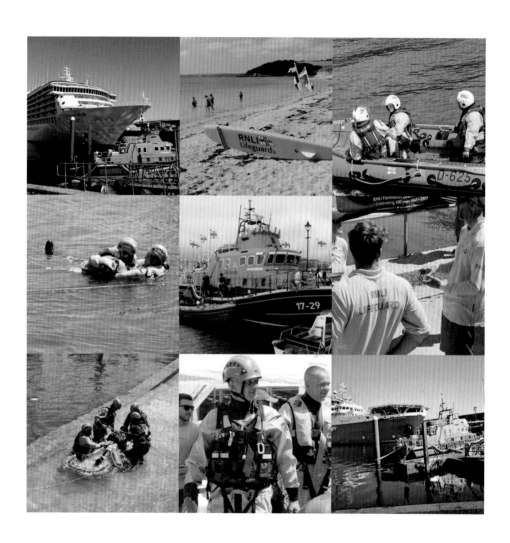

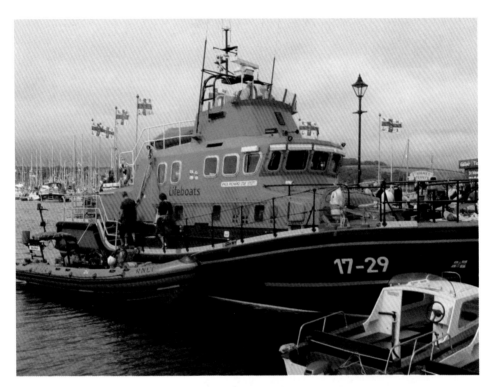

RNLI – Falmouth Lifeboats. The search and rescue operation maintains sterling voluntary work in all weather. The Falmouth lifeboat station is the busiest in Cornwall, and the Richard Cox Scott is its all-weather craft. The RNLI take part in local events, give rescue demonstrations and have a Castle-to-Castle swim annually between Pendennis and St Mawes. They hold a yearly service on Custom House Quay, 'for those in peril on the sea'.

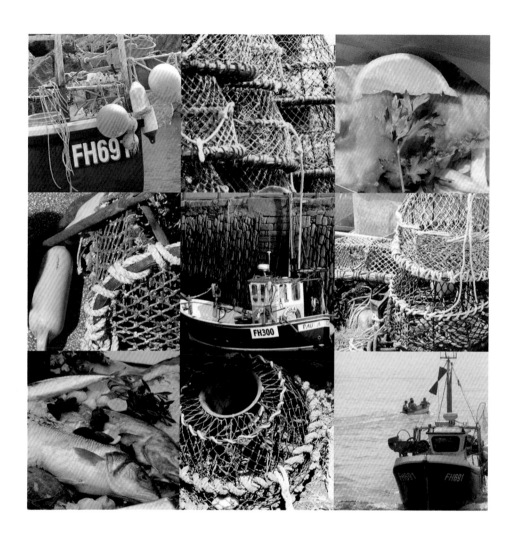

Something Fishy. Falmouth is one of the best coastal spots for fishing in the UK. Pollock, mackerel and flounder can be fished from the pier, and charter fishing trips are available. There are wet fish shops in Falmouth and Penryn, and a stall at the weekly farmers market. There are also several seafood restaurants in town.

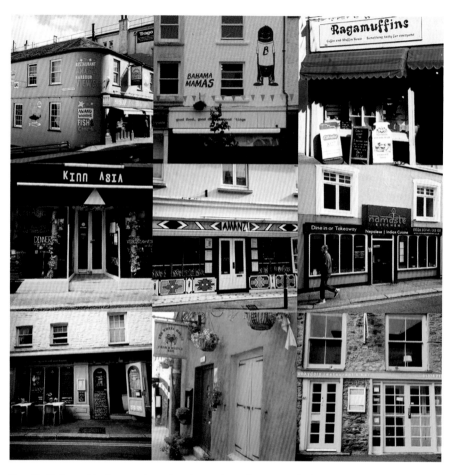

Foodie Falmouth. Remember the days when there was little more to choose from than fish and chips or pie shops? Now one can eat around the world. We are spoilt for choice between Indian, Chinese, Thai, Caribbean, Italian, burger joints, kebab shops and seafood restaurants as well as pub fayre ... the decision takes some making! Cafe culture has also caught on in Falmouth with a big range of coffee and teashops and pavement eating. Yes, Falmouth has become a foodie destination.

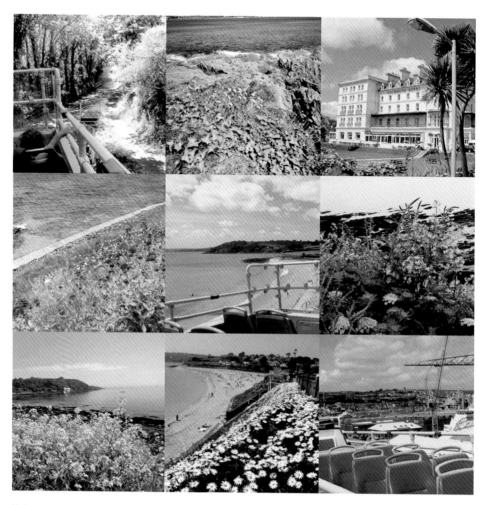

Take an open-topped bus ride around Pendennis Point, along the coast road and past the Falmouth Hotel, to see the magnificent vistas opening up and delight in the floral displays. The hotel, with its beautiful Victorian architecture, was opened in 1865 as the Great Western Railway expanded into Cornwall, bringing a start to tourism in Falmouth.

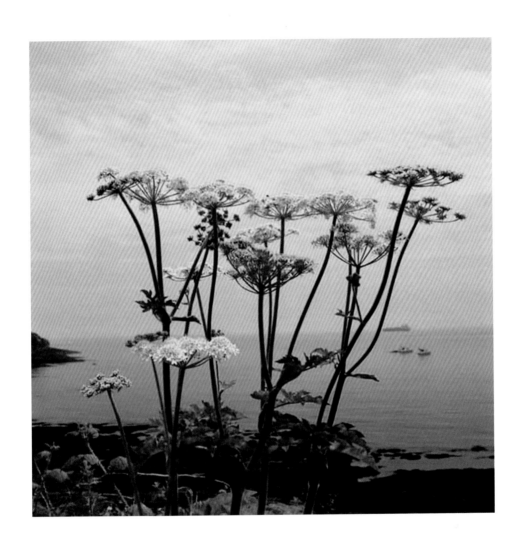

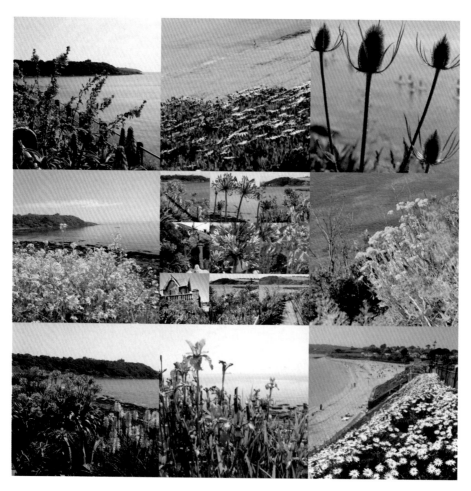

The glorious plantings of agapanthus, osteospermum, succulents and wild flowers are a sight to behold! Queen Mary Gardens, beside Gyllyngvase Beach, is a relaxing oasis. Laid out in a formal style, the gardens are planted up in amazing technicolour each spring with the help of local primary school children. They also have an area of gunnera surrounded by little waterways, framed by Monterey pines.

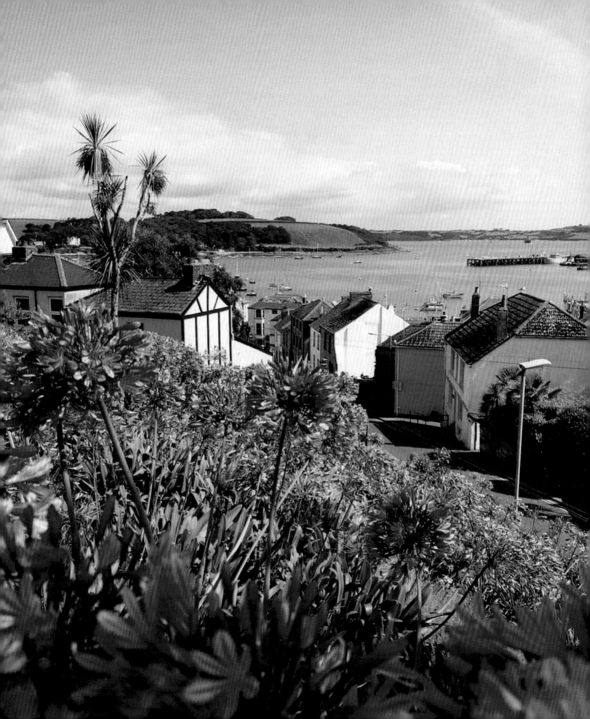

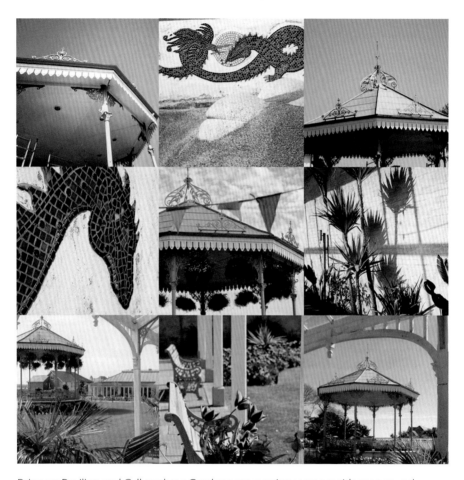

Princess Pavilion and Gyllyngdune Gardens are a unique venue with year-round events including music, theatre and flower shows. The beautiful gardens and verandas have plants from all over the world, and the Edwardian bandstand offers a stage for Sunday afternoon music, often from local brass bands. A monolithic arch on a mound has a seat with stunning views over the bay. A tunnel leads under the road to Tunnel Beach overlooked by a folly, which was probably once used as a summerhouse.

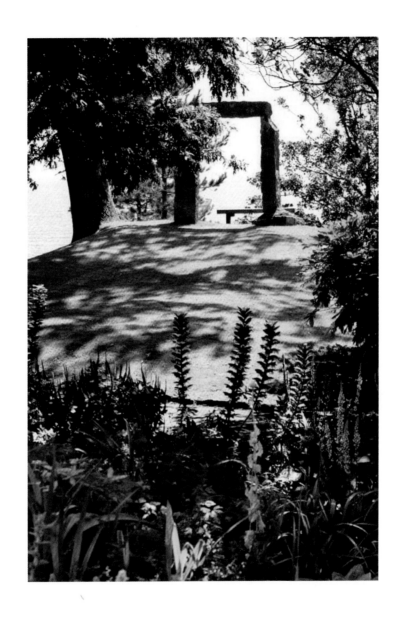

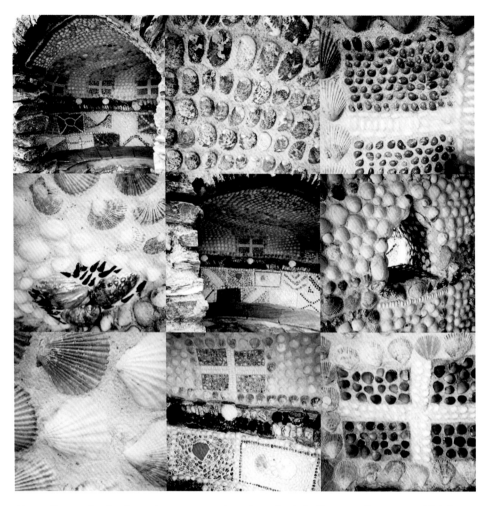

Above the exotically planted quarry are cleverly crafted shell-covered grottos, which have seats affording views out to sea. Decorating with shells was an art form often used by the Victorians. I didn't try counting the variety of shells used!

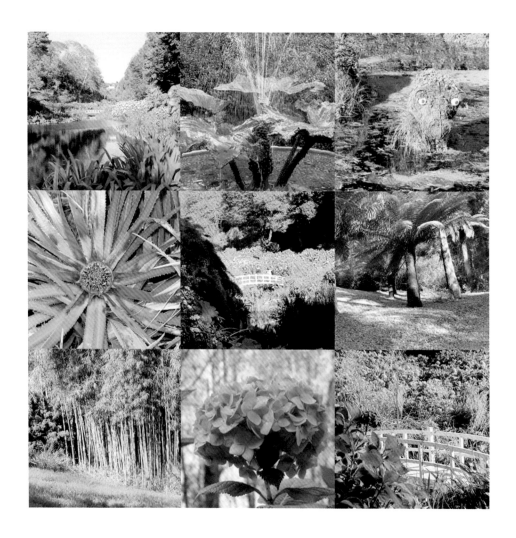

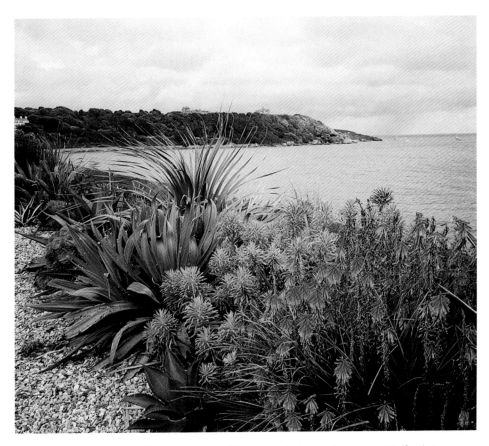

After Monet. Trebah Garden is a wonderful sub-tropical paradise on the Helford River with a private beach. The white bridge spanning the mallard pond is reminiscent of Monet's painting, so I call this grid (**opposite**) 'After Monet.' In late summer the whole valley is a drift of blue hydrangeas – a visual delight, as are the splendid Chusan palm trees. Gunnera and bamboo also feature, and a koi pool prompts a pause to stand and stare.

Falmouth and its outskirts have other spectacular National Trust gardens – Glendurgan and Trelissick are areas of outstanding natural beauty, all year round an ever-changing display of colour and scent.

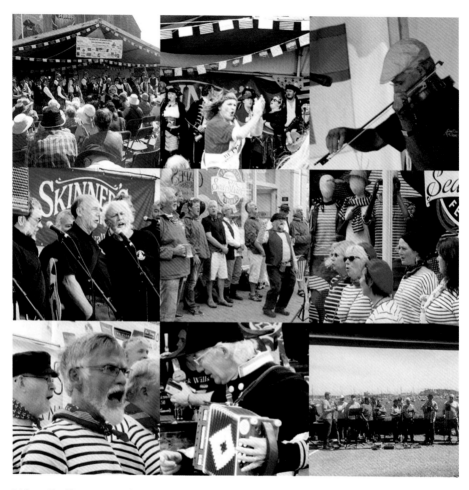

'What Shall We Do with the Drunken Sailor?' Falmouth's international sea shanty festival sees the streets and squares echoing with raucous song and merriment, while beer flows freely. The camaraderie between the shanty groups is sheer joy to watch. Sea shanties were work songs sung on ships during the age of sail, and have long been a part of British music and maritime culture. What joy there is in singing!

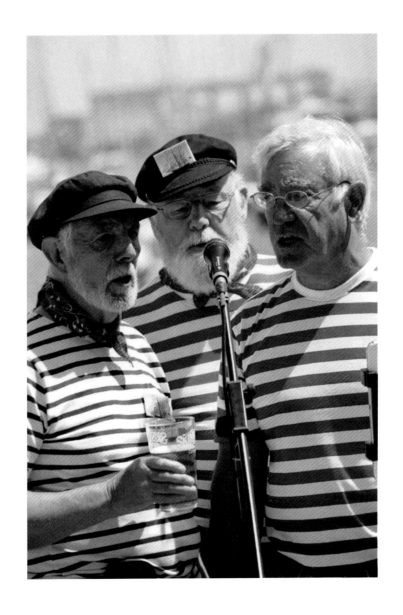

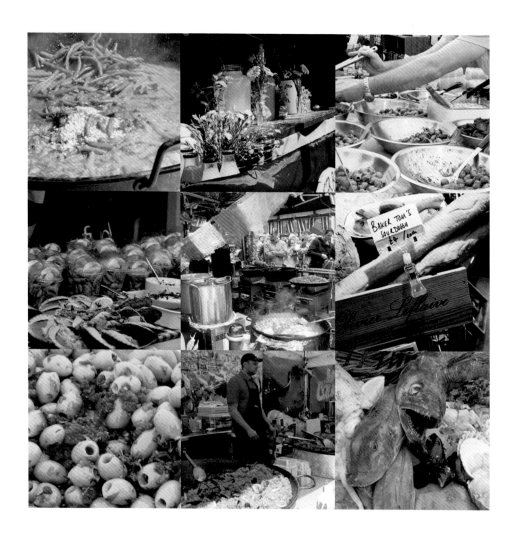

The aromas of International street food fill the air. Hot dogs, candy-floss and seaside rock are no longer the order of the day; in their place are huge pans of paella, curries, Mexican tacos, crepes with a variety of fillings, fruity smoothies and freshly squeezed juices to tempt the palate. Cornish pasties and saffron cakes still make the list, of course.

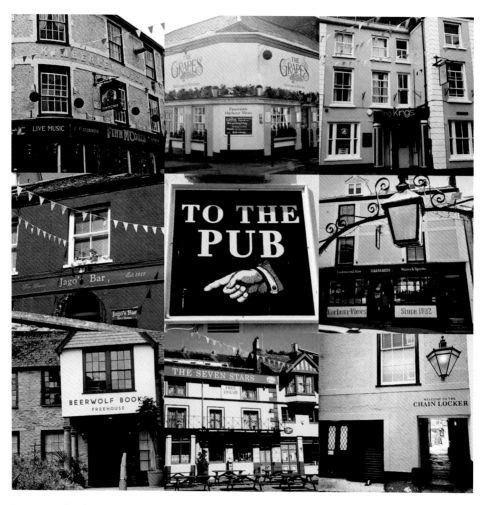

Just a small selection of Falmouth's watering holes, to cater for all tastes – sorry if I have left out your favourite. Do you like quiet and cosy corners, music-playing venues, sports bars, take your own grub or child-friendly pubs? When the sea shanty festival is on, music echoes through many of the town's pubs – take a crawl round to follow the fun.

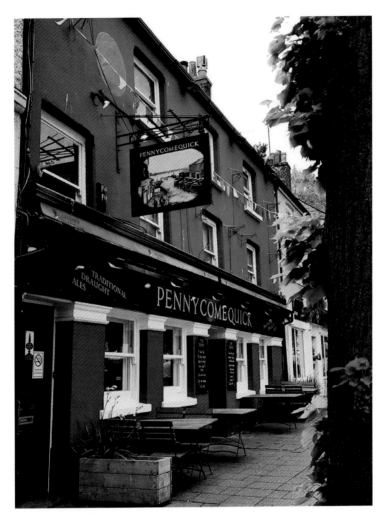

The Penycomequick pub is a play on Falmouth's former name: Pen-y-cwm-cuic, meaning the head of the creek. It dates back to the mid-1700s.

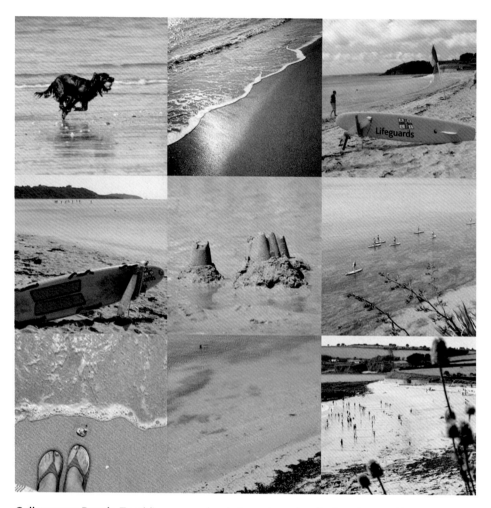

Gyllyngvase Beach. Tumbling waves, buckets and spades, feeling the sand between your toes – 'Oh, I do like to be beside the seaside'! Gylly Beach is ideal for rock-pooling, swimming and paddle-boarding.

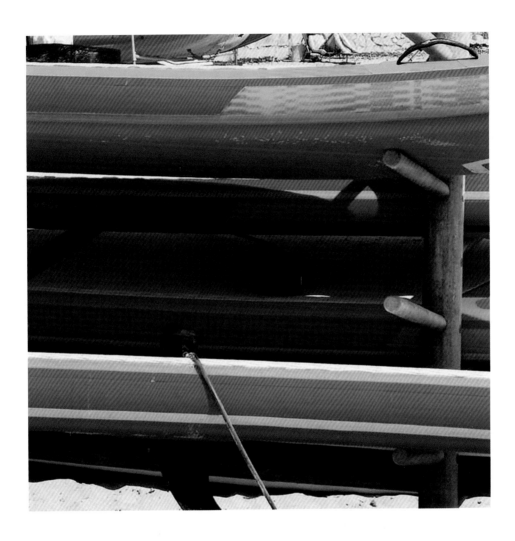

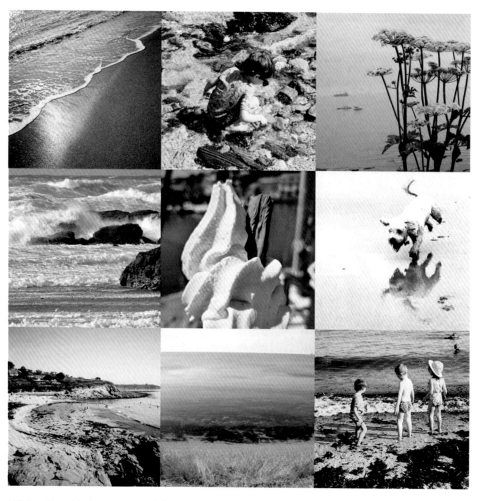

Life's a Beach! Can you smell the sea and taste the vanilla and chocolate ice cream?

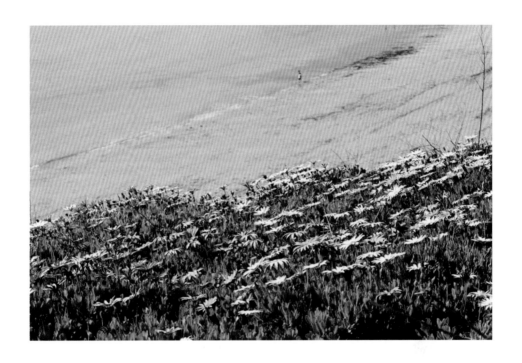

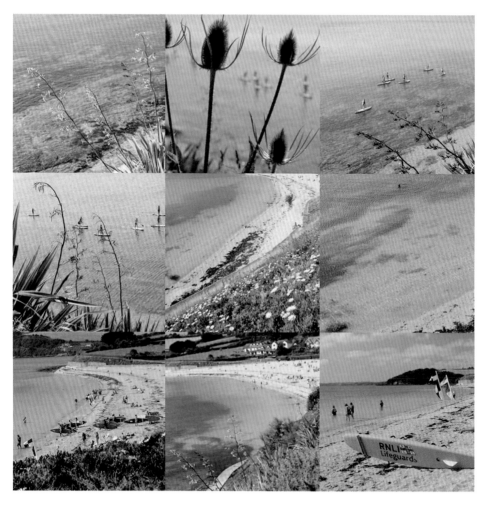

Falmouth Bay. Turquoise seas and paddle-boarding – such idyllic seas for water sports. Falmouth Bay is enclosed by Rosemullion Head and Pendennis Point. It is overlooked by the castle and offers a beautiful walk against a backdrop of exotic flora, unspoiled by commercialism. Plenty of seats provide a place to rest and enjoy the views.

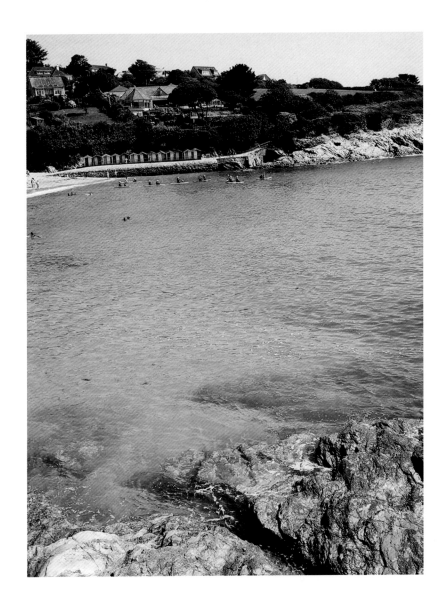

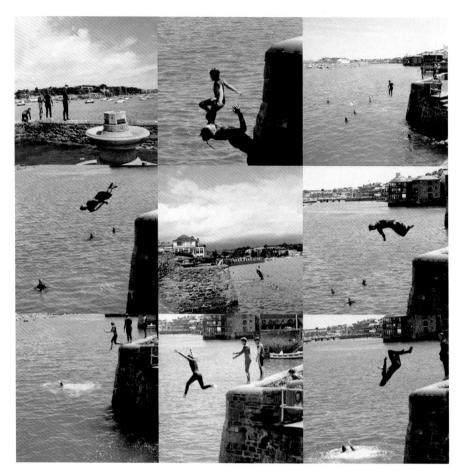

Greenbank Gardens, and School is Out. Diving and tombstoning off harbour walls can be dangerous, but summer days bring the joy-seekers out onto the harbour walls. I watch them performing and note that they seem to take care, waiting for a clear area of sea before the jump. It has been a seaside occupation for generations; old folk talk of their own memories of diving off harbour walls as youngsters, but love to boast of their hardiness because they didn't wear wetsuits!

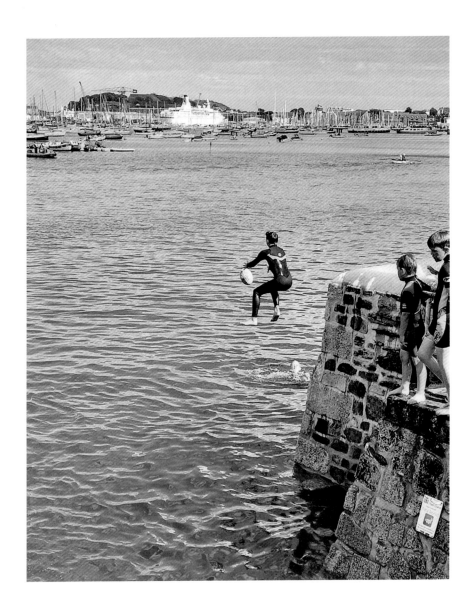

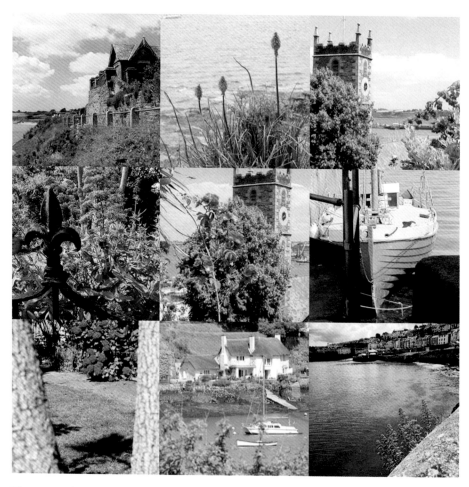

The Days of Our Summer. Idyllic vignettes of summer days in Falmouth. A view of Swanpool between the trees after walking the coastal path from Gylly. A thatched cottage across the water in Flushing. Valerian clinging to the harbour wall and wild roses framing the tower of King Charles the Martyr church. Red-hot poker flowers standing sentinel against a backdrop of the sea.

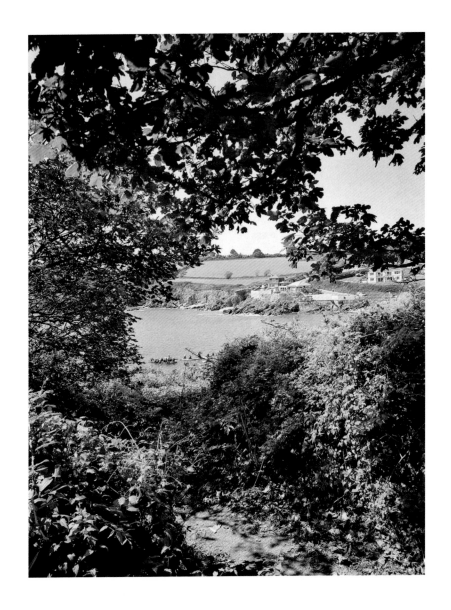

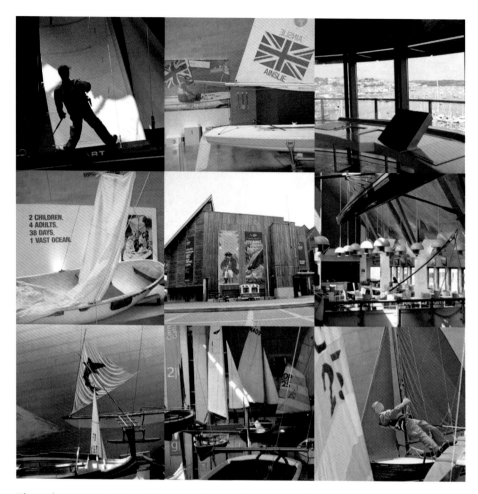

The Falmouth Maritime Museum. Opened in 2003, the Falmouth International Maritime Museum is where Cornwall's seafaring heritage is charted. Exhibits about the Packet Ships that carried the British Empire's post in and out of Falmouth harbour for almost 200 hundred years, Olympic winning dinghies and stories about survival at sea are just a few of the themes giving insight into our maritime history.

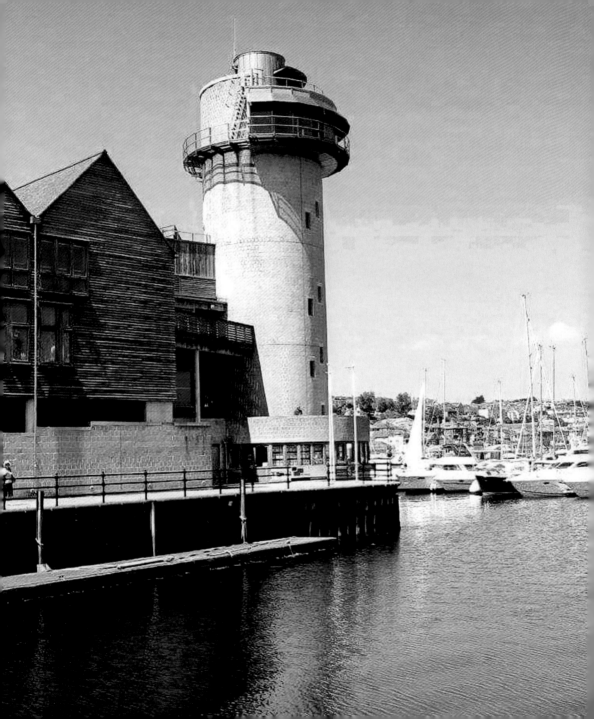

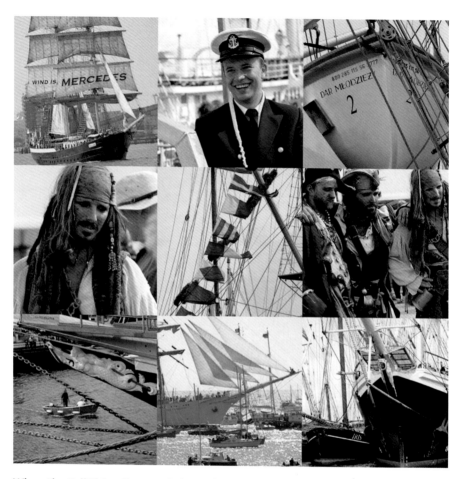

When the Tall Ships Came to Falmouth. In 2014, forty-three vessels from around the globe took part in a regatta before the majestic 'Parade of Sail' and the journey on to London. What a privilege to have the opportunity to clamber over those impressive vessels and try to imagine what life was like at sea. I was lucky enough to stay with a friend near Greenwich after seeing the event in Falmouth, and so experienced the spectacle both on the open seas and Old Father Thames.

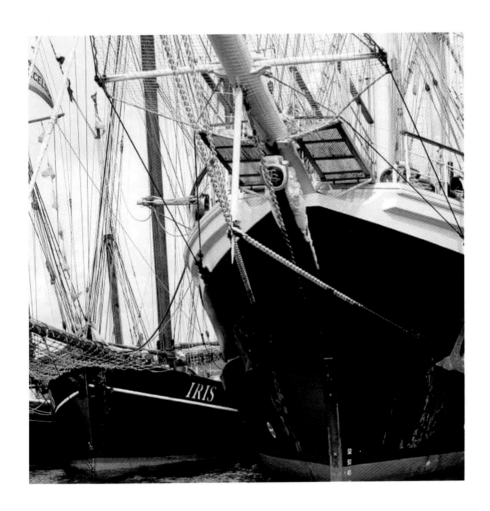

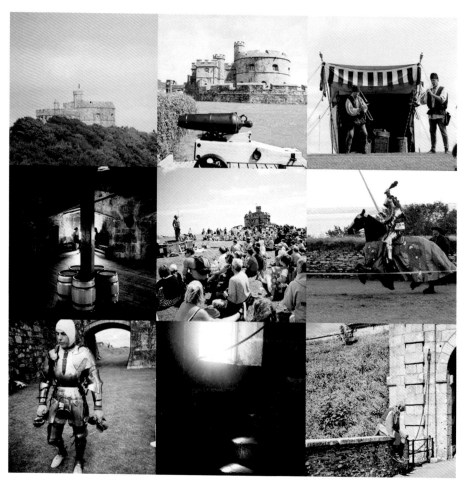

Pendennis Castle and a window of Little Dennis Blockhouse. What mysteries unfold here? Originally built by Henry VIII to defend the Carrick Roads waterway from invasion, it is now run by English Heritage. The discovery centre is packed with hands-on activities. Events include medieval jousts and feasts, falconry, Second World War stories and theatre productions.

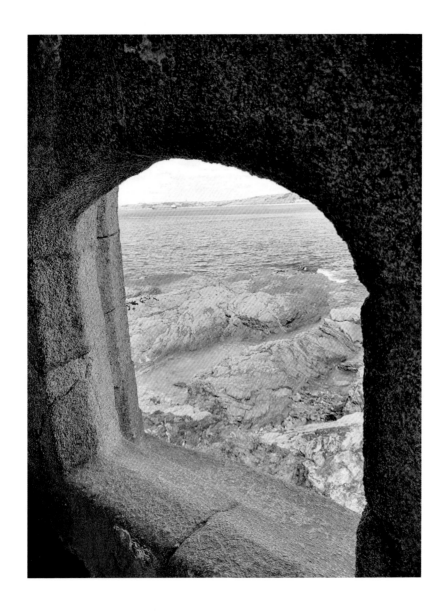

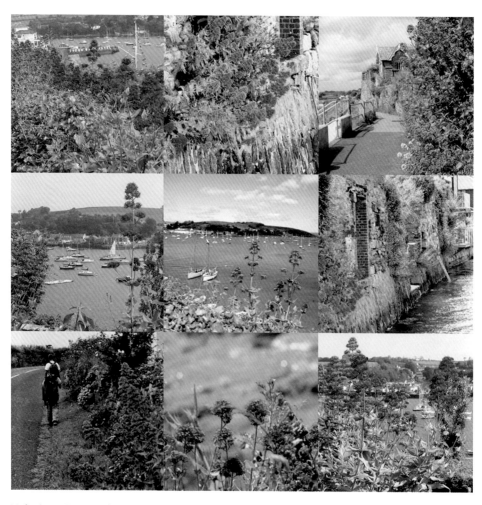

Valerian. Giving Falmouth a blush of pink. It grows on walls, sea-cliffs and rocks thriving near the coast.

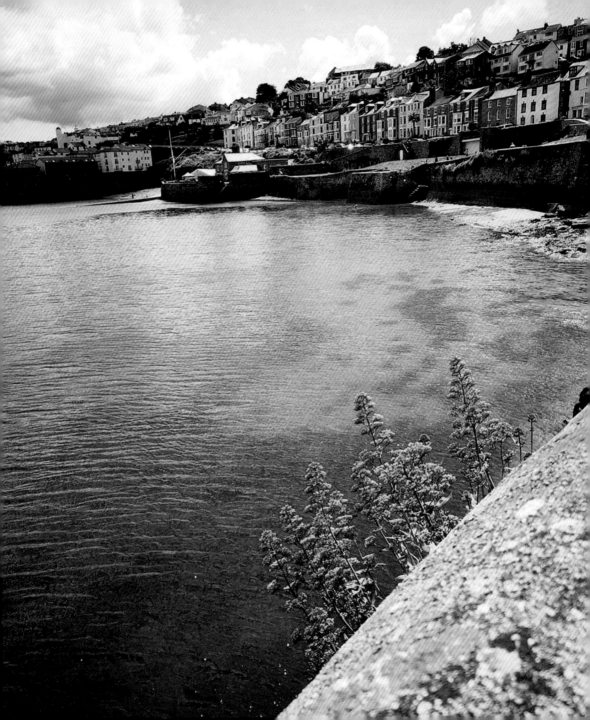

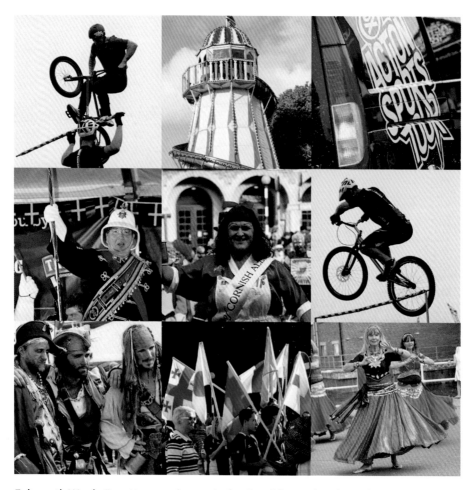

Falmouth Week. Regatta, parade, music, food and fireworks. The sailing regatta is the largest in the south-west, and Falmouth's amphitheatre-like setting is the ideal locale to enjoy the spectacle. Many houses facing the harbour are decked out with flags, the streets are alive with buskers, food stalls and an aeronautics display, and Action Sport stunt bike riders provide thrills for the crowds.

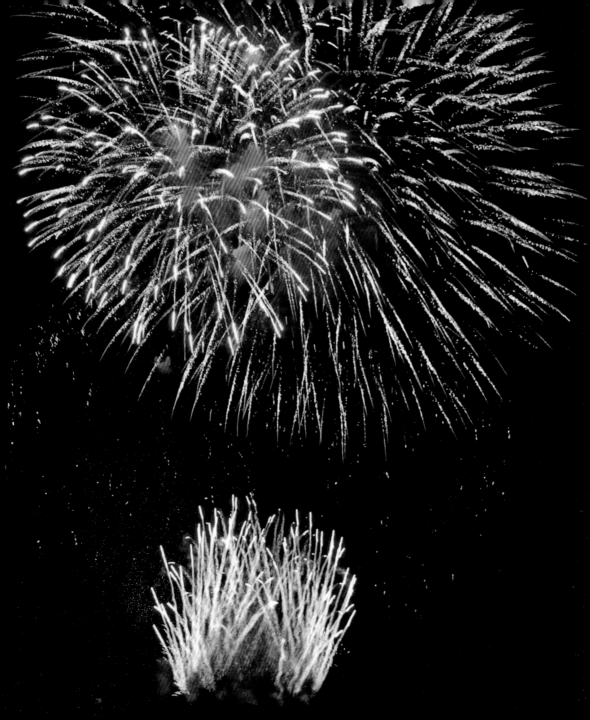

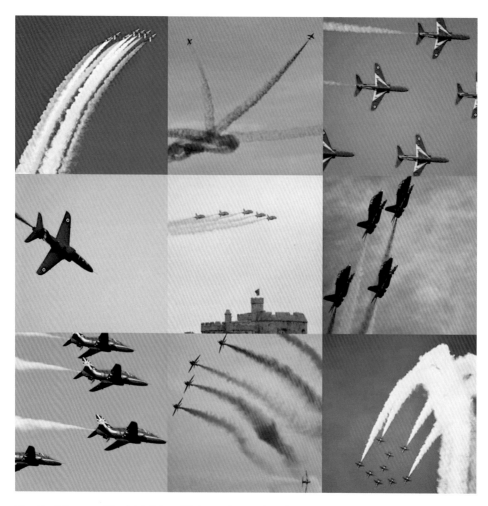

The Red Arrows. The highlight of Falmouth Week is the Royal Air Force Aerobatic Team flying Hawk single-engine jets in an awe-inspiring spectacle of speed and precision, to the enchantment of the thousands who assemble on every vantage point to watch.

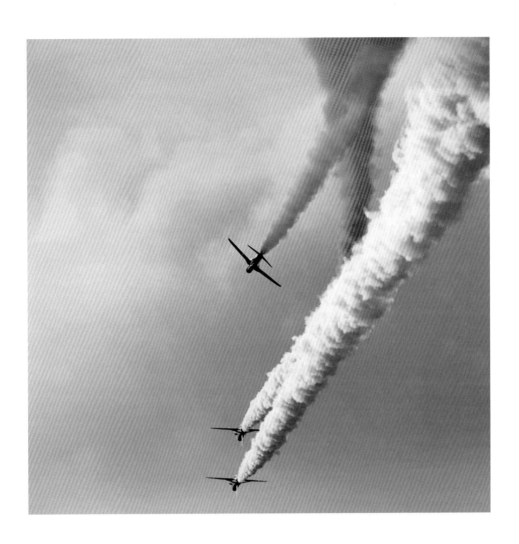

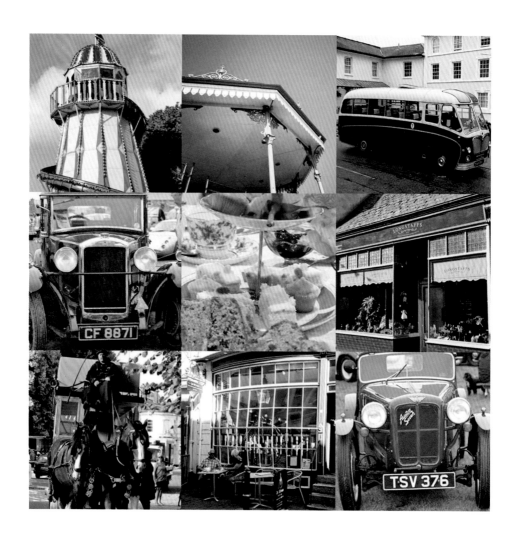

Images of Yesteryear in Falmouth. There is a welcome resurgence of interest in times past – not just nostalgia for things past, like those helter-skelters and merry-go-rounds, but an appreciation of the quality of artisan produce, the elegance of past street furniture and sign writing, the magic of a Victorian-style Christmas. This is evidenced in Falmouth by the number of vintage shops, knitting circles, artisan bakers and even a dress-making shop in the high street where one can book garment-making sessions. The Old Brewery Yard often features a Victorian-style Christmas event with braziers roasting chestnuts, handmade gifts and snowflake machines.

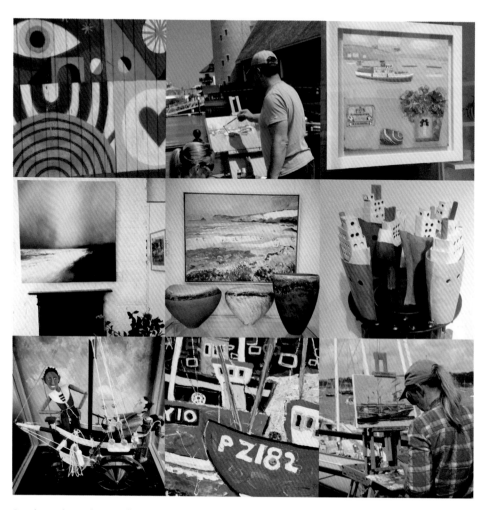

See how the colours of Falmouth inspire the painters and potters. Marine life, the patina of stone, stormy skies, fishing boats, turquoise seas, rock pools and rusty chains – all sources of inspiration to the creative people who provide the gallery shops with their work.

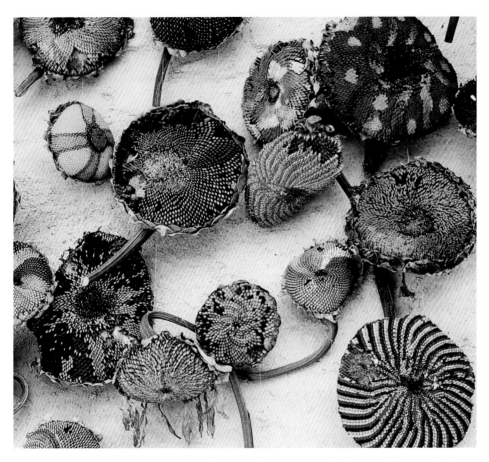

Exhibitions. Falmouth's art scene is vibrant and energetic, with the art gallery, university open days, The Poly cultural centre, gallery shops, murals and open house events. The art gallery houses an impressive collection of works, and recently hosted an amazing automata project entitled 'A Cabaret of Mechanical Movement'. Elsewhere in town, artist Jo Clarkson's 'Fibonacci Flowers' – a community art project involving local schools and groups – resulted in sunflower seed heads being painted in Fibonacci patterns, which were hung on a wall under the Princess Pavilion's verandas.

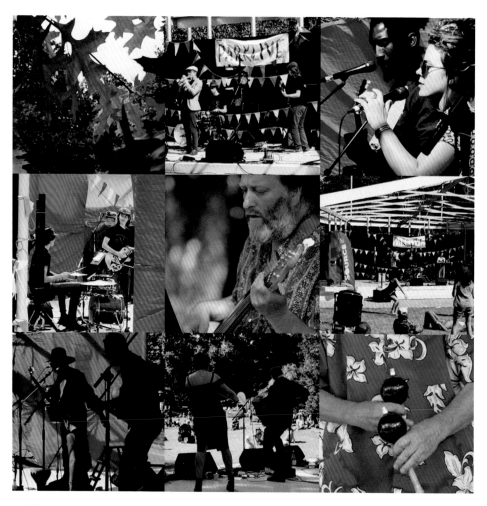

Parklive. Live music in Kimberley Park on a summer's day, a community event showcasing a range of local talent. A great opportunity to picnic in the seven-acre oasis of Kimberley Park. The park was presented by the Earl of Kimberley to the people of Falmouth in 1877.

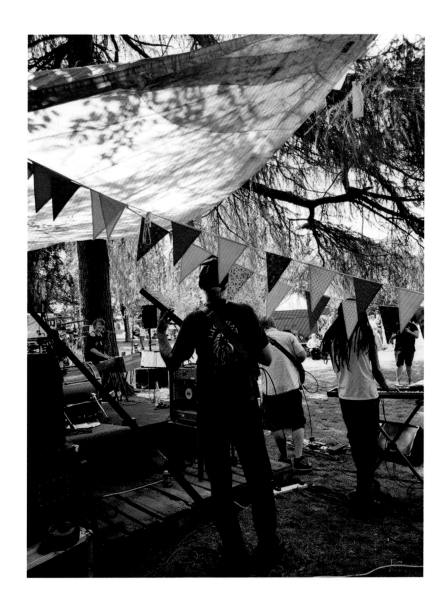

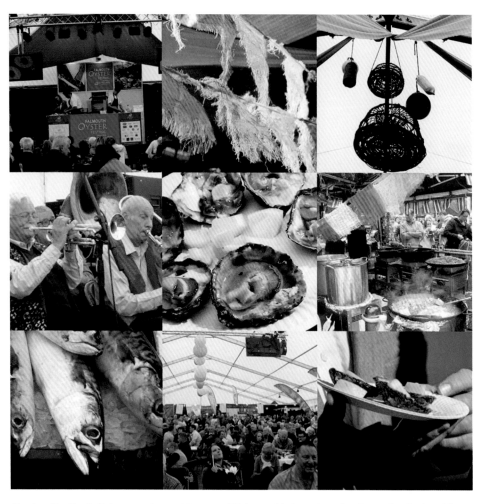

Oyster Festival. This annual event is one of Falmouth's best loved culinary festivals, with a Grand Oyster Parade, music, cookery demonstrations, a race for working boats, and arts and craft stalls. Many celebrity chefs have cooked there including Antonio Carluccio OBE, John Burton-Race and Hugh Fearnley Whittingstall, as well as head chefs from local hotels.

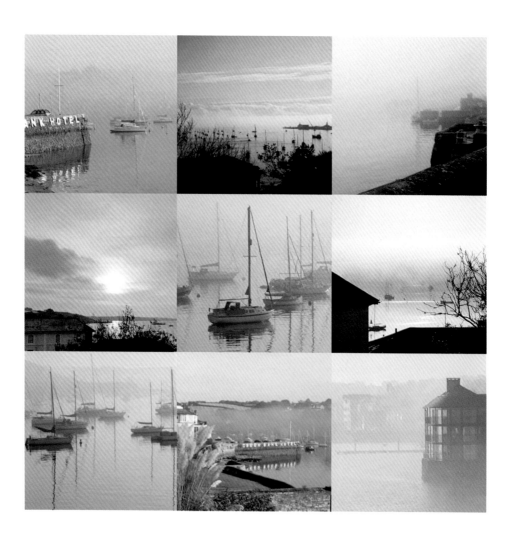

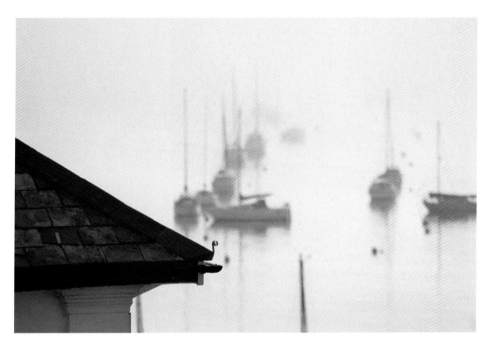

Sea mist provides an atmospheric and eerie light in Autumn months. Those tiny droplets of water hanging in the air completely obscure the boats in the harbour until it burns off, or hangs in low clouds of mist forming a halo effect. I remember on one spectacular misty morning when I went out to photograph it, a policeman stopped beside me and got out his phone to do the same and we exchanged pleasantries about the wonders of nature.

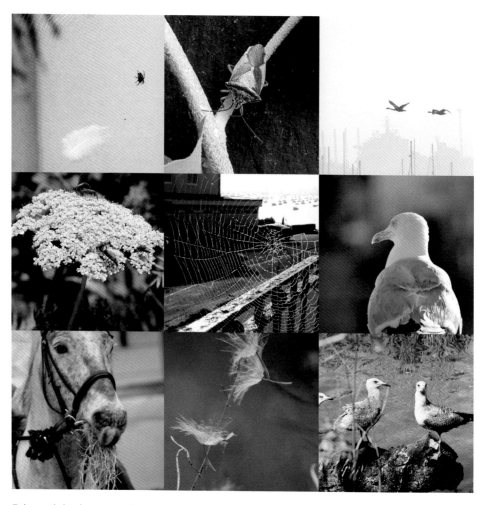

Falmouth harbour caught in the web. Nature watching is a rewarding pastime. One can observe Canada geese flying over the harbour with the docks looming in the background, a spider's web framing boats in the harbour, dandelion clocks caught on a spiky stem and the wonderful pondlife at Swanpool Nature Reserve. Nature is balm for the soul.

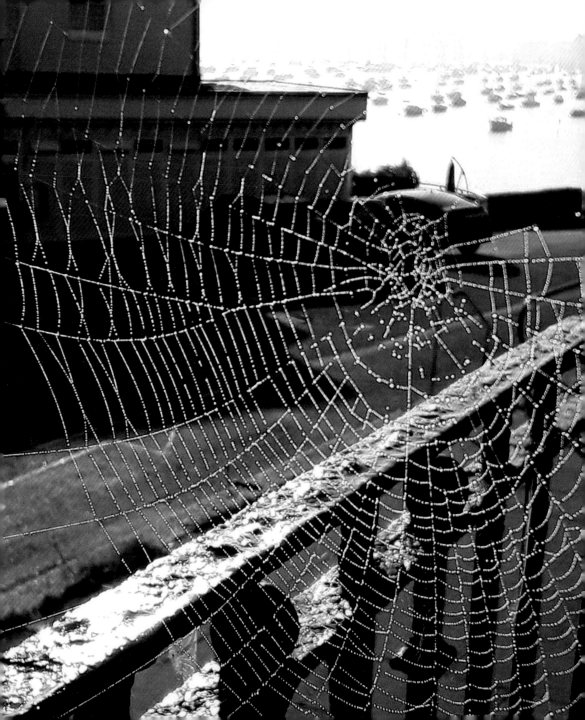

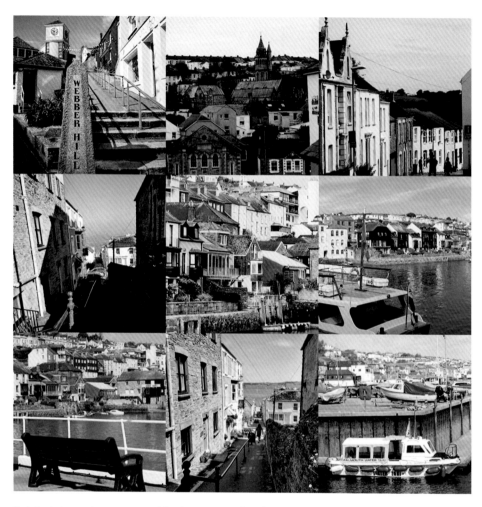

Painted stucco terraces tumble down to sea level in Falmouth. One obtains a certain level of fitness, because wherever you walk, it is up hill and down dale. The impressive terracing is best viewed from a boat in the harbour.

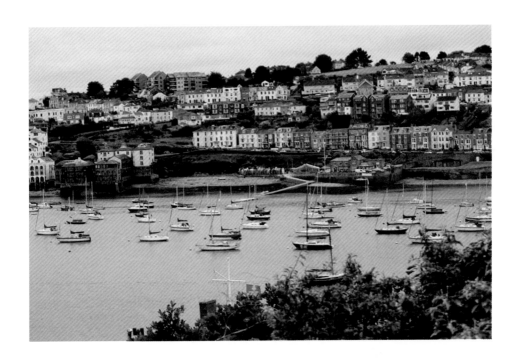

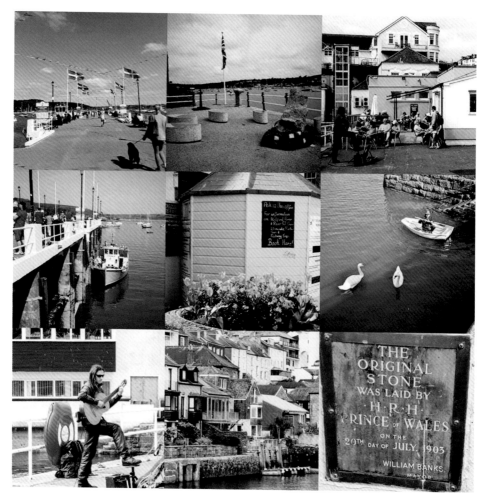

The Prince of Wales Pier. The foundation stone was laid in 1903 by HRH Prince of Wales, later crowned King George V. It is one of Falmouth's ferry hubs for boat visits to beauty spots across the estuary; a great spot to just sit and watch life on the water and listen to the musician who plays there daily.

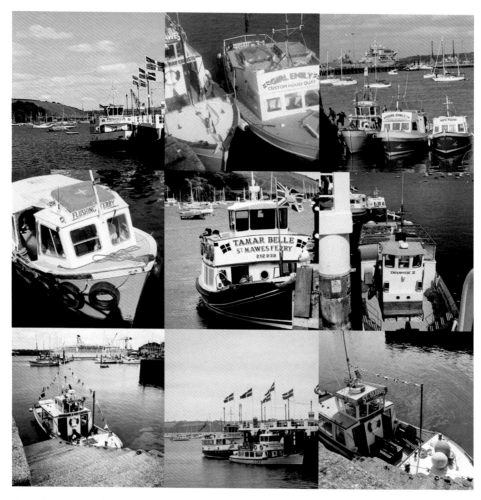

Ferry Me Across the Harbour. From the Prince of Wales Pier or Customs House Quay, one can take ferry rides to Flushing or St Mawes, or pleasure boats up the Carrick Roads to Truro or Trelissick National Trust Gardens. Another boat ride takes one out on the open sea, across Falmouth Bay and along the Helford Passage – lovely days out leaving roads behind.

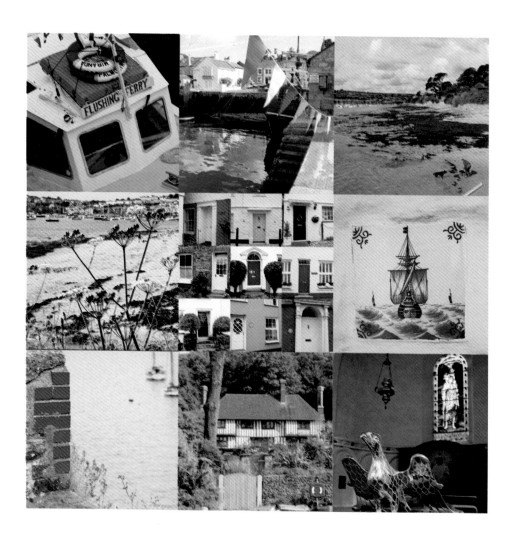

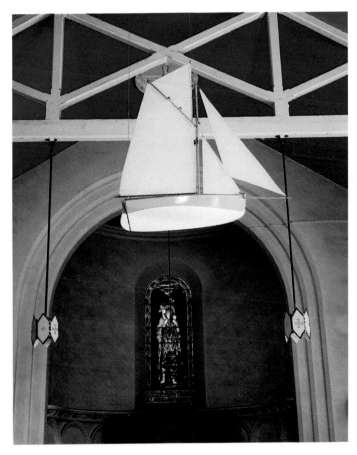

Flushing. This coastal village is a short ferry hop across from Falmouth. It was settled by a Dutch community in the seventeenth century. Various ship captains from the packet ships built themselves impressive Queen Anne-style houses there. The village itself is charming, with St Peter's Church, two pubs, a village green, a small handful of shops and a close community. A pleasant walk around the Trefusis headland brings us to Mylor Yacht Harbour. Trefusis Beach is the place to go to find bright yellow periwinkle shells and enjoy views over Falmouth Docks.

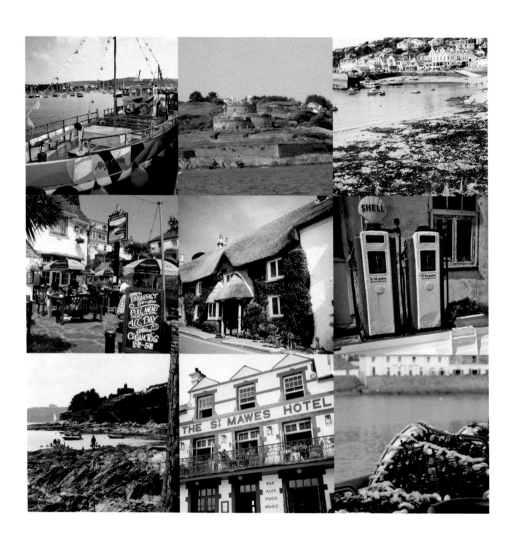

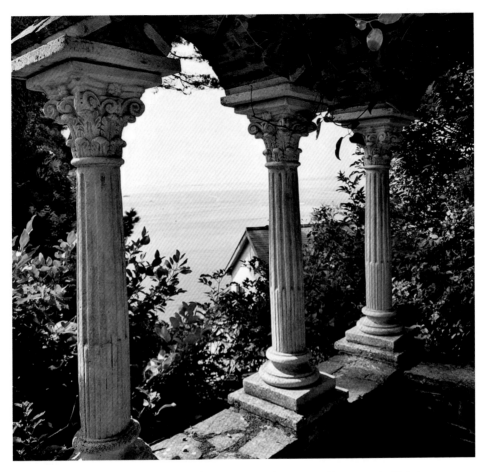

St Mawes is a small coastal town opposite Falmouth, situated in a wooded inlet. Formerly an old fishing port, now it is a favourite spot for yachting people and artists, and a popular tourist destination. It has its own castle, turquoise waters, the stunning Lamorran Gardens, and a continental vibe. There are upmarket hotels and eating places and characterful pubs. On the Roseland Peninsula, which has been designated part of Cornwall's Area of Outstanding Natural Beauty, there are many stunning walks.

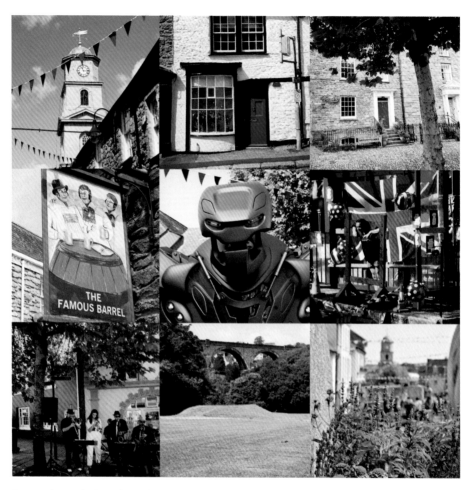

Penryn lies side by side with Falmouth on the Penryn River. It was a port of some significance in the fifteenth century, an old market town steeped in history. There is interesting architecture from an assortment of periods, including Tudor, Jacobian and Georgian. The Town Hall building houses a museum containing many curiosities and relics from Penryn's domestic past. The Clock Tower dates from 1839.

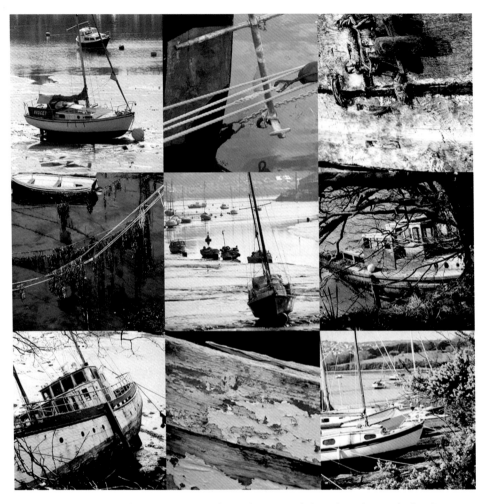

The creek at Penryn is home to herons, houseboats and abandoned vessels that lie derelict in the mud beside the riverbank.

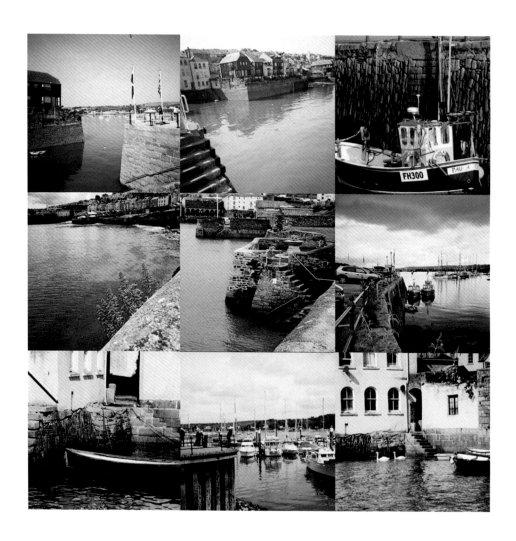

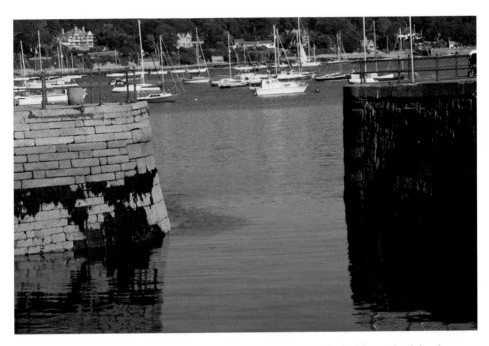

Harbour Walls. These distinctive historic quay walls, many of which were built by the Dutch engineers and builders also involved in much of the construction of Falmouth harbour, are worth more than just a passing look.

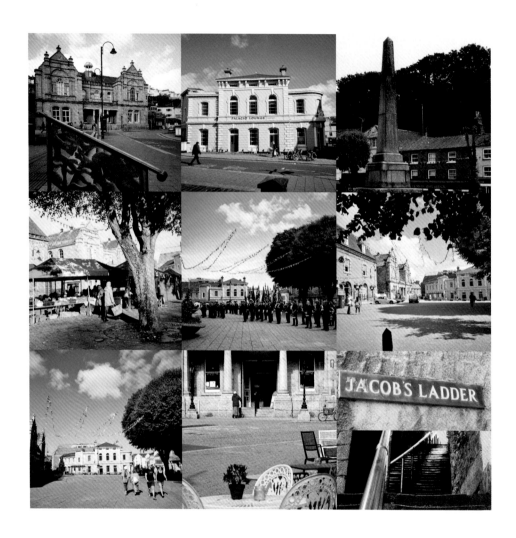

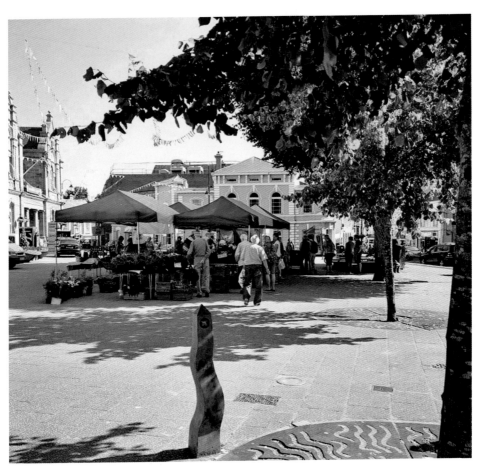

The Moor is a piazza surrounded by the solid and solemn granite facades of the civic building and the Methodist Church. It has held a market for hundreds of years and is the focal point of many events in the area, as well as having a bus terminal that links to other parts of Cornwall. Nearby is the 111-stepped staircase of Jacob's Ladder, built in the 1840s by Jacob Hamblen, a local businessman who wanted to connect his home on the upper terraces to his place of work.

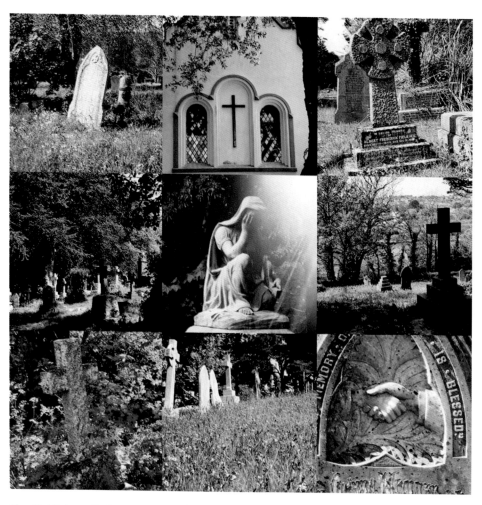

The Old Falmouth Cemetery is such a peaceful resting place, overlooking Swanpool Nature Reserve. Wild flowers, including a carpet of bluebells in Spring, are offset beautifully by the granite gravestones.

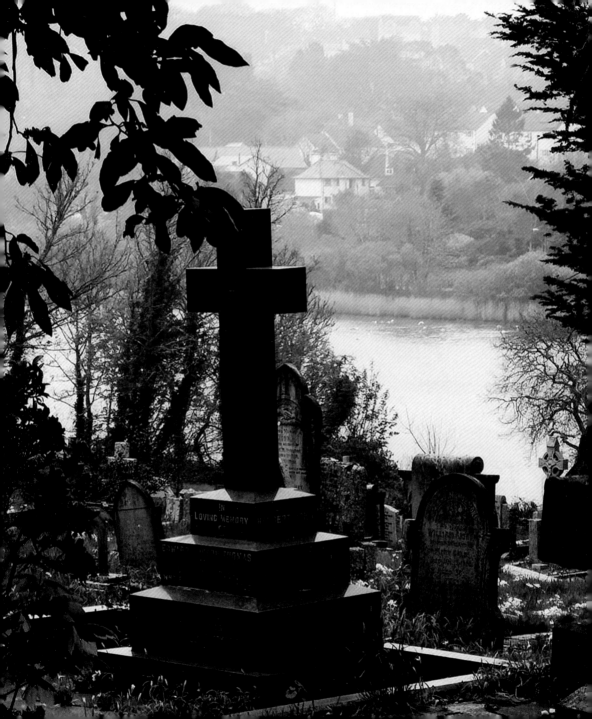

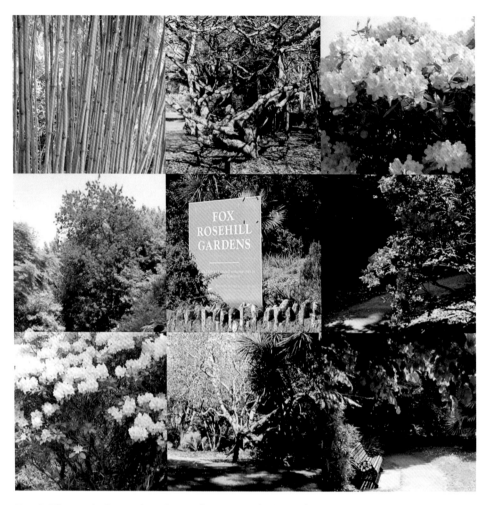

Exotic Plants. A pioneering plant collector, geologist Robert Were Fox naturalised many exotic plant species from New Zealand and Australia in the 1820s, and created Fox Rosehill Gardens. The mild and moist climate and the warming waters of the Gulf Stream have created ideal conditions in sheltered parts.

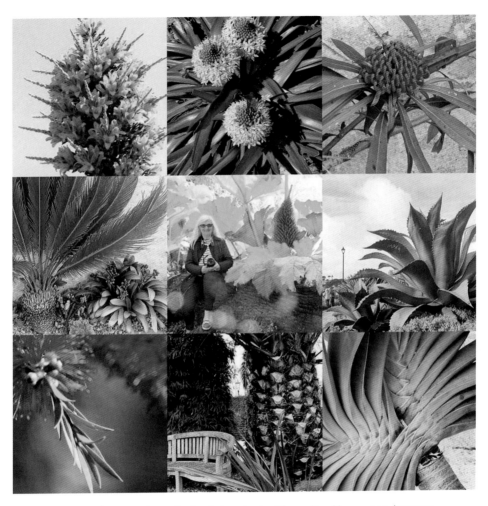

Many of the gardens can be called sub-tropical, with exotics like protea, banana, Australian bottlebrush, eucalyptus, tree ferns, gunnera, bamboos, pampas grass, ginger lilies, Cornish palms, agaves, yuccas and giant echiums. I love exploring and drinking in the scents of these special paradises.

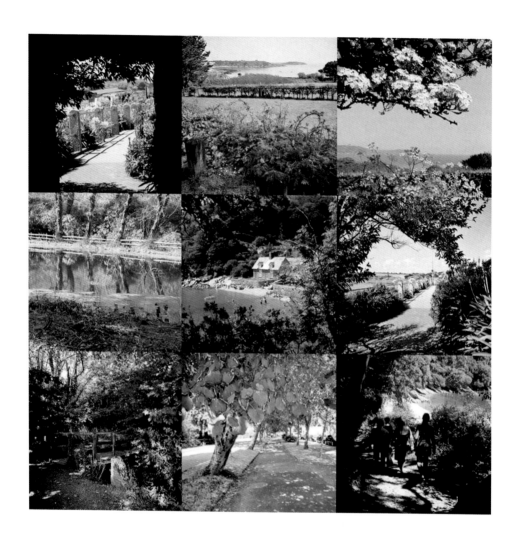

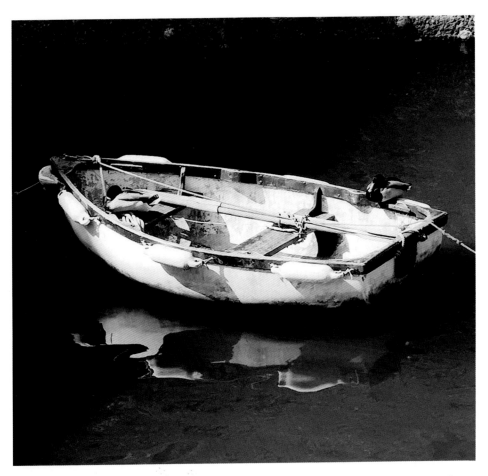

Walking our green and pleasant land. There are a plethora of trails covering coastal paths, from Pendennis Point to Swanpool, Maenporth and then along the Helford River, through Durgan and beyond. Woodland walks in the Glasney Valley in Penryn take you towards the imposing structure of the College Wood viaduct. Glorious walks take explorers from St Gluvias Church, through wooded areas, graveyards, fields of cows, reeds, river bank and, finally, scrubby beaches and refreshments upon arrival at Flushing.

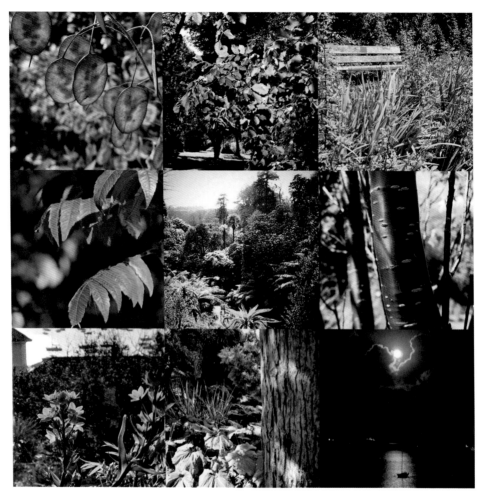

Autumn brings beautiful colours to tropical gardens and the low sun casts its mellow light over the water.

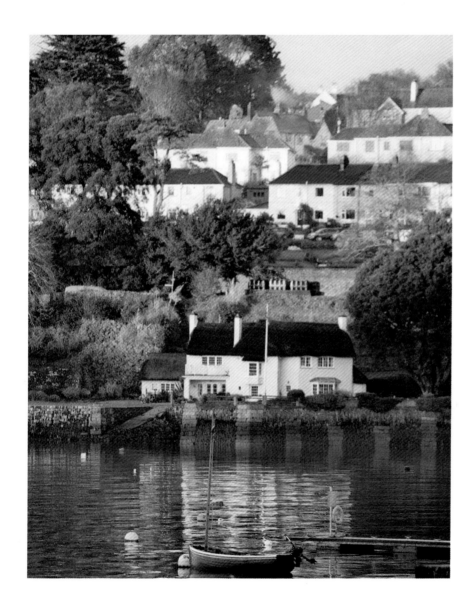

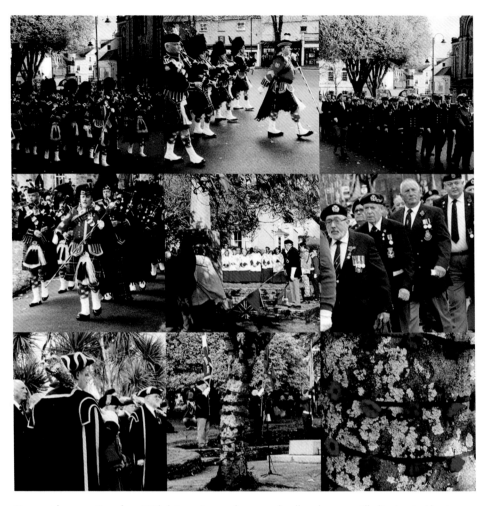

Remembrance Sunday. With late autumnal sun and yellow leaves still clinging to the trees, the Armistice Parade leaves the Moor for a service that includes a two-minute silence and laying of the wreaths beside the war memorial in Kimberley Park. Lest we forget.

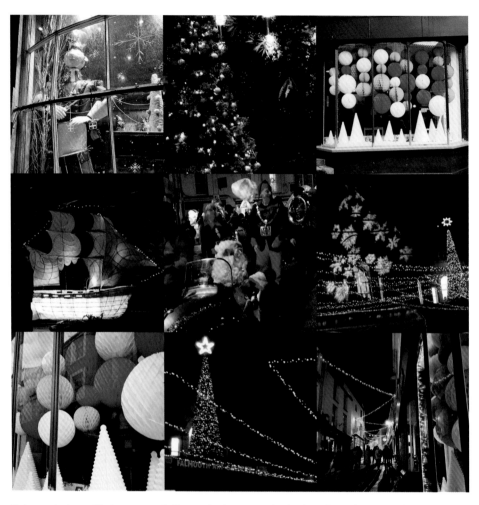

Falmouth does Christmas well. Shop windows are decked, Father Christmas leads the lantern parade and a good atmosphere is created at the switching on of lights.